ideals® EASTER

*A light exists in spring not present on the year
at any other period—when March is scarcely here.
A color stands abroad on solitary fields
that science cannot overtake but human nature feels.*
—EMILY DICKINSON

ideals®

NASHVILLE, TENNESSEE

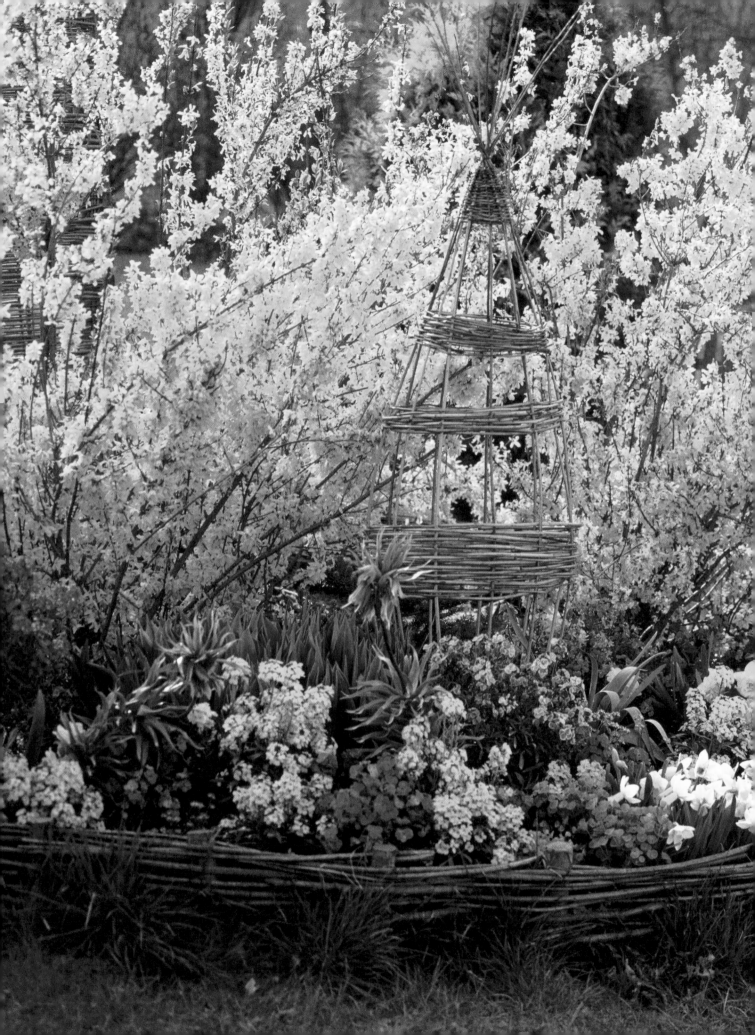

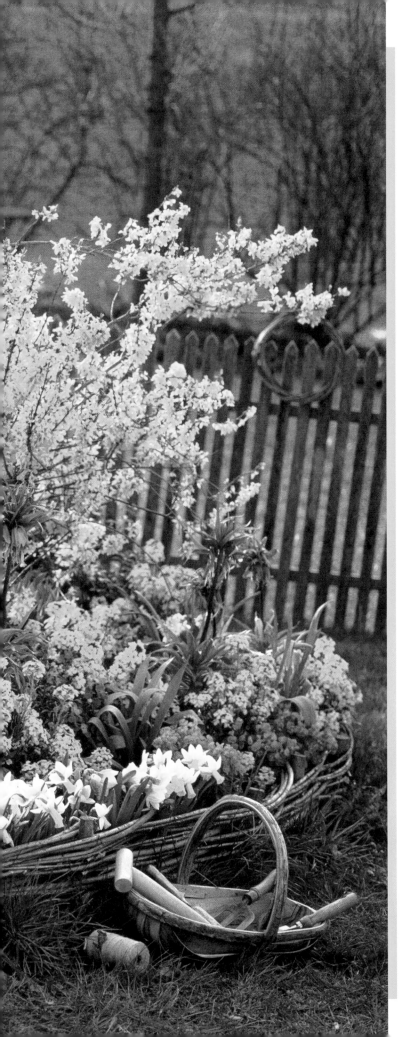

Resurrection
Eileen Spinelli

Robin chirps his sweet spring song.
The creek, the pond frogs sing along.
The maple sways to a happy breeze,
and there's a hum of honeybees.
Come out to dance in April sun.
Rejoice that life and love have won.

I Wonder
Gary A. Fellows

I wonder what it's like to live
where never comes the spring
in climates where it's all the same—
where seasons never bring
changes in the natural world,
no creatures on the wing
from far away returning
full of joyous praise to sing;
where winter's awkward leaving
can't initiate a fling;
where resurrection's power,
seen in every living thing,
is not what one discovers
while on walks, meandering;
where nature's hallelujahs
cause no chapel bells to ring.

Image © Friedrich Strauss/GAP Photos

Sweet Spring
Marianne Coyne

Sweet spring!
What hidden mystery sleeps beneath your bough,
for us, only a peek you will allow?

What hidden song awaits its perfect mate
within winged lovers, who with restlessness,
 can't wait?

What hidden blossom braves the last
 remaining snow
and with God's grace endeavors forth to grow?

Tis spring! The season of rebirth
that captivates each heart with boundless mirth.

The Signs of Spring
Mary Wells

The melting snow begins to fade,
green blades began to sprout;
the buds are swelling, soon to burst,
and leaves are coming out.

The robin's hopping, all a-twitter;
she's come to build her nest;
the smell of spring is in the air;
and in its finery all nature's dressed.

In anticipation of each day,
we look for signs anew;

tiny blossoms, pink and white,
the willow tree, its golden hue.

We're out of hibernation now,
the kids are playing, riding bikes;
there's laughter in the balmy breeze
and people strolling, taking hikes.

Spring is such a special time
when flowers bloom so bright;
our spirits once again renewed
as winter says good night.

Image © Aflo Relax/Masterfile

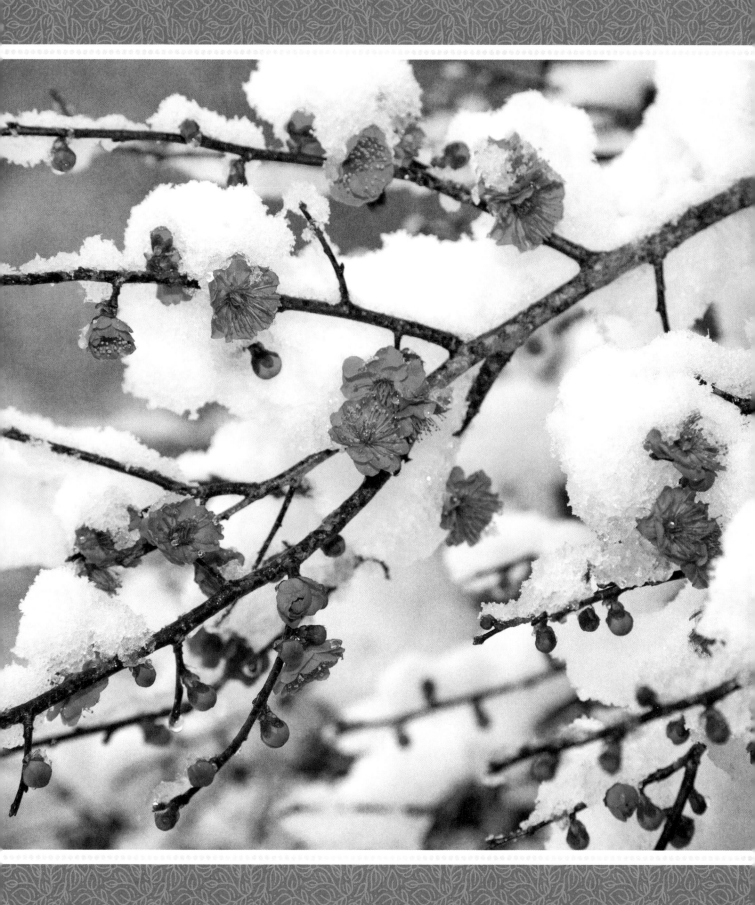

FROM

The Spirit of Poetry

Henry Wadsworth Longfellow

There is a quiet spirit in these woods
that dwells where'er the gentle
 south wind blows;
where, underneath the white-thorn, in the glade,
the wild flowers bloom, or, kissing the soft air,
the leaves above their sunny palms outspread.

That spirit moves
in the green valley where the silver brook,
from its full laver, pours the white cascade,
and, babbling low amid the tangled woods,
slips down through moss-grown stones with
 endless laughter.

And frequent on the everlasting hills,
its feet go forth when it doth wrap itself
in all the dark embroidery of the storm,
and shouts the stern, strong wind.

And here, amid
the silent majesty of these deep woods,
its presence shall uplift thy thoughts from earth,
as to the sunshine and the pure, bright air
their tops the green trees lift.

Then her breath,
it is so like the gentle air of spring,
as, front the morning's dewy flowers, it comes
full of their fragrance, that it is a joy
to have it round us; and her silver voice
is the rich music of a summer bird
heard in the still night with its
 passionate cadence.

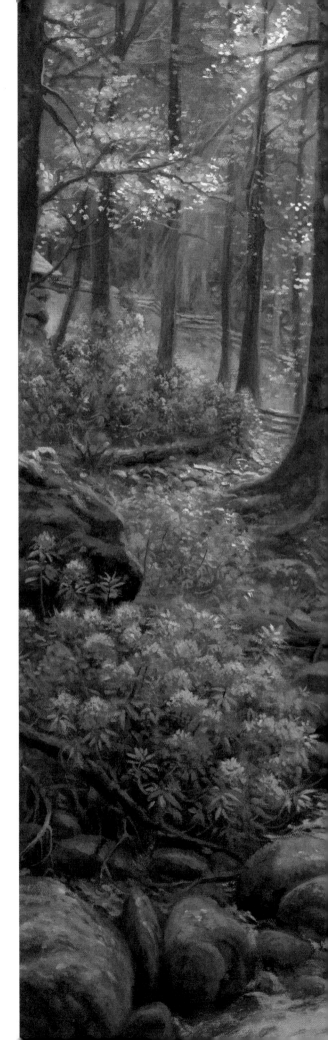

NATURE'S HARMONY *by Mark Keathley.*
Image © Mark Keathley

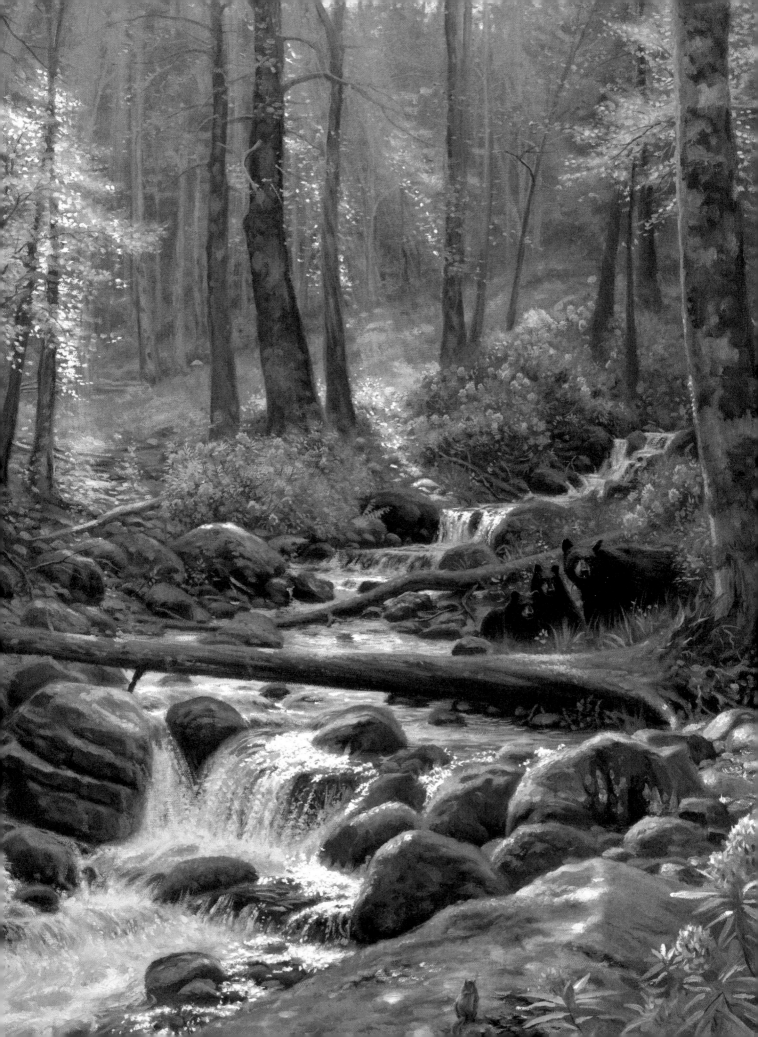

Fly a Kite!
Eileen Spinelli

I made a kite with
paper, wood, and string.
On the first sunny day
I took my kite out the door
to wide green fields
and ran
and hoped with all my heart
that it would soar.

And when it did—
go high and bright as any
 April bird—
I got all teary-eyed,
because my wishful heart—
so happy—
had no words.

Wind on the Hill
A. A. Milne

No one can tell me,
nobody knows,
where the wind comes from,
where the wind goes.

It's flying from somewhere
as fast as it can,
I couldn't keep up with it,
not if I ran.

But if I stopped holding
the string of my kite,

it would blow with the wind
for a day and a night.

And then when I found it,
wherever it blew,
I should know that the wind
had been going there too.

So then I could tell them
where the wind goes . . .
but where the wind comes from
nobody knows.

CROSSWINDS by Bonnie White. Image © Bonnie White Folk Art

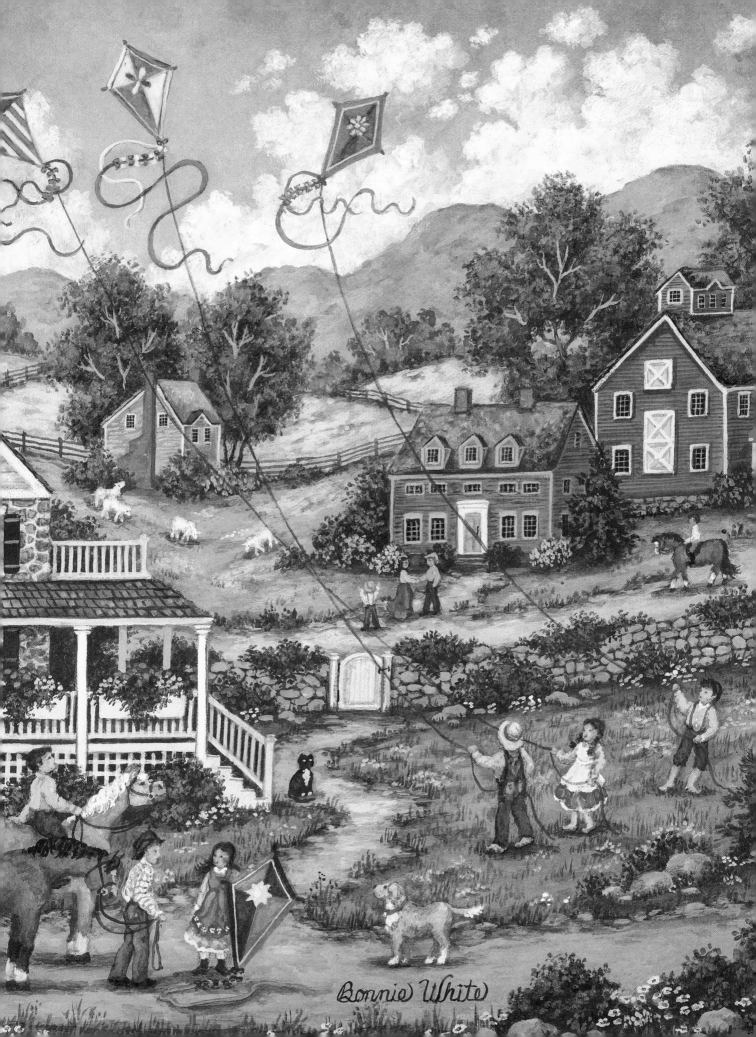

Bonnie White

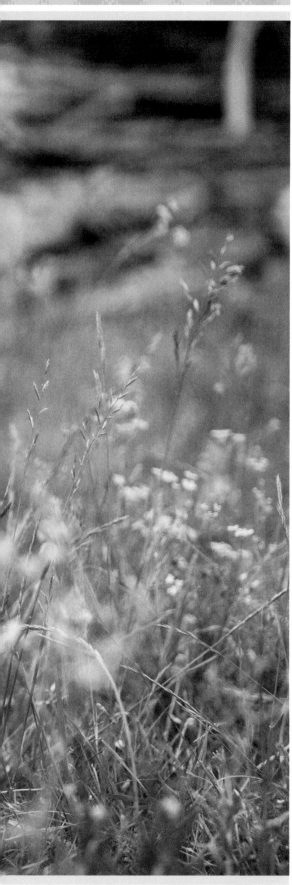

There Was a Child Went Forth
Walt Whitman

There was a child went forth every day,
and the first object he looked upon,
that object he became,
and that object became part of him
for the day or a certain part of the day.
Or for many years or stretching cyles of years.
The early lilacs became part of this child,
and grass and white and red morning glories,
and white and red clover, and the song of
 the phoebe bird.
And the third-month lambs and the sow's
 pink-faint litter,
and the mare's foal and the cow's calf,
and the noisy brood of the barnyard
or by the mire of the pond-side,
and the fish suspending themselves so curiously
 below these
and the beautiful curious liquid,
and the water-plants with their graceful flat heads
all became part of him.
The strata of colored clouds,
the long bar of maroon-tint away solitary by itself,
the spread of purity it lies motionless in,
the horizon's edge, the flying sea-crow,
the fragrance of salt marsh and shore mud,
these became part of that child who went
 forth every day,
and who now goes, and will always go
 forth every day.

Image © Belyaaa/AdobeStock

Saturday at the Farmers' Market

Deborah A. Bennett

The year I learned to eat, I was twelve years old. My family moved from the big city to the smallest town I had ever seen, and I was a city kid who loved food that came in boxes and bags, reconstituted by boiling or frying or heating on the stovetop until it rose inside amazing Jetson-like aluminum-foil domes. Fresh fruit, like apples and oranges, were reserved for special occasions, such as decorating glass bowls on a table beside the tree at Christmastime.

The spring we moved to the country, I discovered where food came from. On a weekend trip to a real working farm, we picked strawberries right off the vine and ate them, still warm from the sun. We carried home boxes and boxes of berries to freeze and to cook into preserves that lasted all year long. There were shadowy cornfields that stood not far from our home, lush green hills dotted with black and white cows, and red horses that wandered the meadows all day. Roosters crowed at dawn and quails whistled beside silver barns that shone in the distance like mirages.

Mother planted her little orchard of peach trees in our backyard that held the promise of peach pies and peach cobblers and thick, sweet peach slices preserved in Mason jars for the winter. Elsewhere on the property grew other fruit trees planted long before us. There were apple trees for apple pie and applesauce and crisp, raw apples to munch, just because we could. We fought the birds for the cherries on the cherry trees, dreaming of cherry preserves and luscious cherry pies; and we braved the thorns of blackberry vines just for the sake of blackberry dumplings and hot blackberry cobbler still bubbling in its dish.

One Saturday in April, we discovered the farmers' market. The whole town had turned out in the city park to hear the live music, eat homemade ice cream in cones, and dance to the local band. But the biggest surprise to me was the row after row of tables spread with vegetables I had never seen before: green, yellow, and red bell peppers, deep purple globes of an unheard-of eggplant, giant-sized zucchini squash, which I was to discover was heaven when baked and sprinkled with cheese. By evening, I saw my first fireflies of spring, twinkling like tiny stars all around us.

On the ride back home, I thought of the tomato plants, started from seed but now sagging with fruit, like ornaments dangling on a Christmas tree. No more food from bags or boxes for us. Now, all we had to do was reach out and pluck the juicy, fresh goodness of nature.

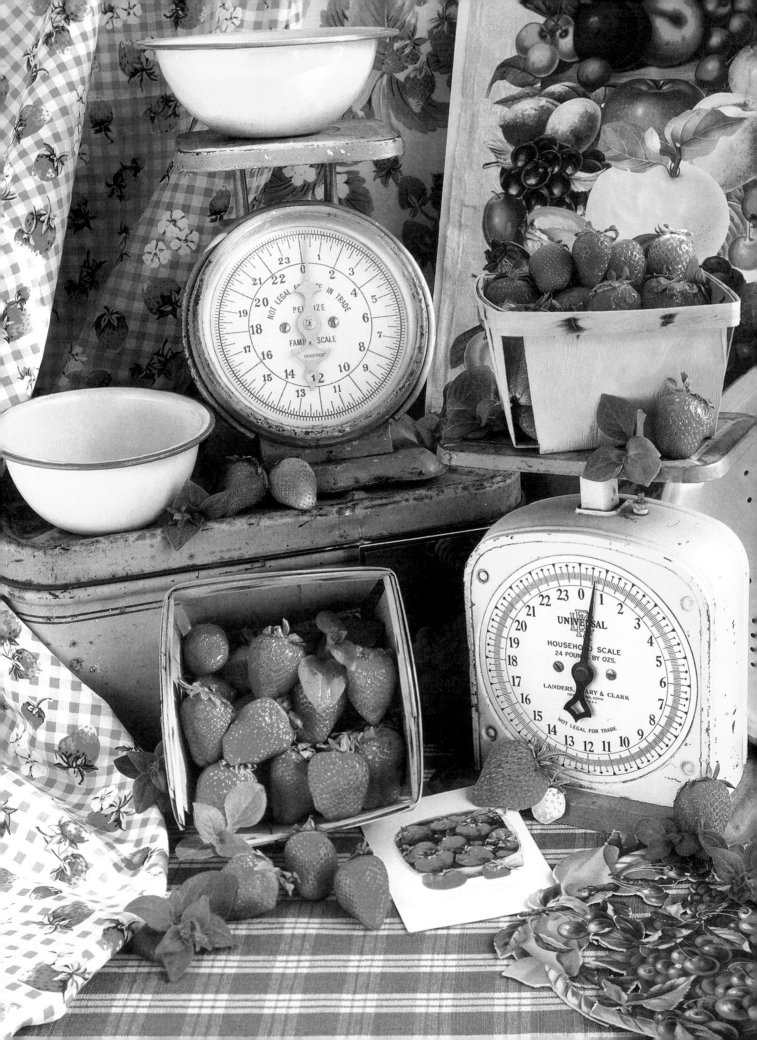

Warm Friends

Joan Donaldson

A steady drizzle fell one spring morning as I milked our goat Rosemary. Yesterday's sunshine had vanished as the weather wrestled with the lingering winter days; and even the blooming purple crocuses couldn't convince me that Easter would arrive in another week. Rosemary had come to our farm as a milking doe while our young goat Poppy was round and close to giving birth. But today, as the damp, cool air swirled into the barn, I hoped the young mother-to-be would wait for a warmer day. Although goats are hardy animals, the birthing chapter in my goat manual warned how newborn kids should not be exposed to chilly drafts.

Glancing over at Poppy, I noticed how she paced back and forth, pawing the straw; signs she had entered the early stages of labor. Just as Poppy was a yearling who had never kidded, I was a new goat keeper who had never managed a birthing. I prayed that the labor would resemble the descriptions in my goat book so I would understand how to help her. Oblivious to my concerns, Poppy arranged the straw into a nest and lay down. After fetching a bucket of warm water sweetened with molasses and other supplies, I knelt next to Poppy, offering her sips of water and encouraging words. Like those first crocuses illustrating the imminent arrival of spring-

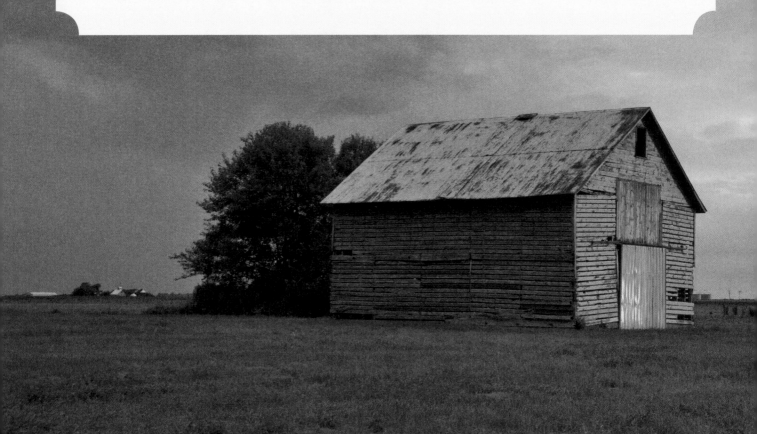

time, Poppy concentrated on bringing forth new life. When the first kid arrived, I dried him off and waited to see if she would birth a second one, but she did not.

A new concern popped up. Baby goats spend much of their first week nestled with their siblings sleeping, but this little fellow didn't have a buddy to cuddle. When Poppy walked to the pasture or stood at the manger eating, he would grow cold. In fact, Poppy was more interested in eating hay than in caring for her shivering baby. A gust of wind rattled the barn doors. Because our barn had no electricity, I couldn't hook up a heat lamp to stop his quivering.

I trekked to the house and searched for a couple of beach towels. I swaddled the little kid with one towel and then tucked the other around him, yet he continued to shiver. Like the tips of the daffodils trying to emerge from the chilly soil, he needed warmth.

Our calico cat, Bethena, dropped with a thud from the hayloft into the stall and inspected the recent arrival. Circling the kid, she purred while rubbing her soft fur against his little face. Finally, Bethena wrapped her body around the baby and the two buddies snuggled. By mid-afternoon, the mist had lifted; and out in the pasture our does nibbled on the first tender shoots of grass, as a bluebird sang from a fence post. In the goat stall, the unusual pair of friends still slept. The newborn kid was another sign of spring as the days grew longer and the earth awakened.

Image © Donnelly-Austin Photography

April Maiden
Charlotte Partin

When I saw April yesterday,
she wore her hair a different way,
with silken strands spread on the hills
that intertwined with daffodils.

Her lovely lips were ruby red,
daisy garland round her head;
she had a basket with supplies
of robins' eggs and butterflies.

In lacy stockings to her knees,
she decorated dogwood trees,
then dusted off the shy sunbeams
and planted violets by some streams.

She blew kisses through the air,
pine trees swayed in great fanfare,
then shouts of exaltation came,
"Hooray, hooray, it's spring again!"

April
Sara Teasdale

The roofs are shining from the rain.
The sparrows twitter as they fly,
and with a windy April grace
the little clouds go by.

Yet the backyards are bare and brown
with only one unchanging tree—
I could not be so sure of spring
save that it sings in me.

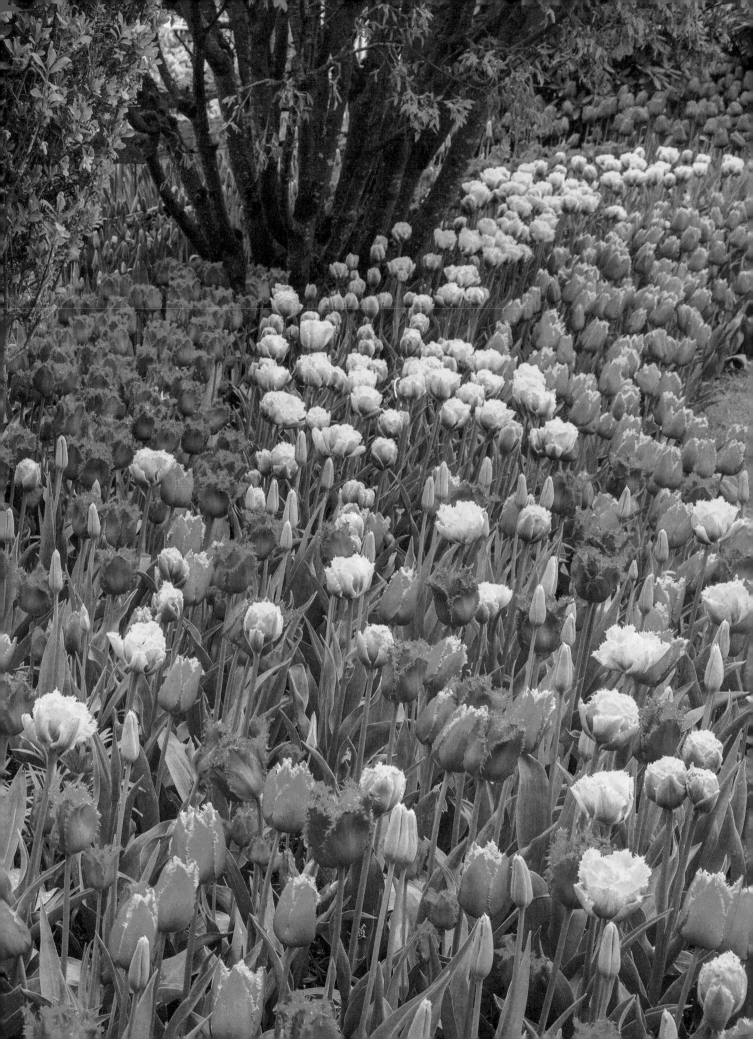

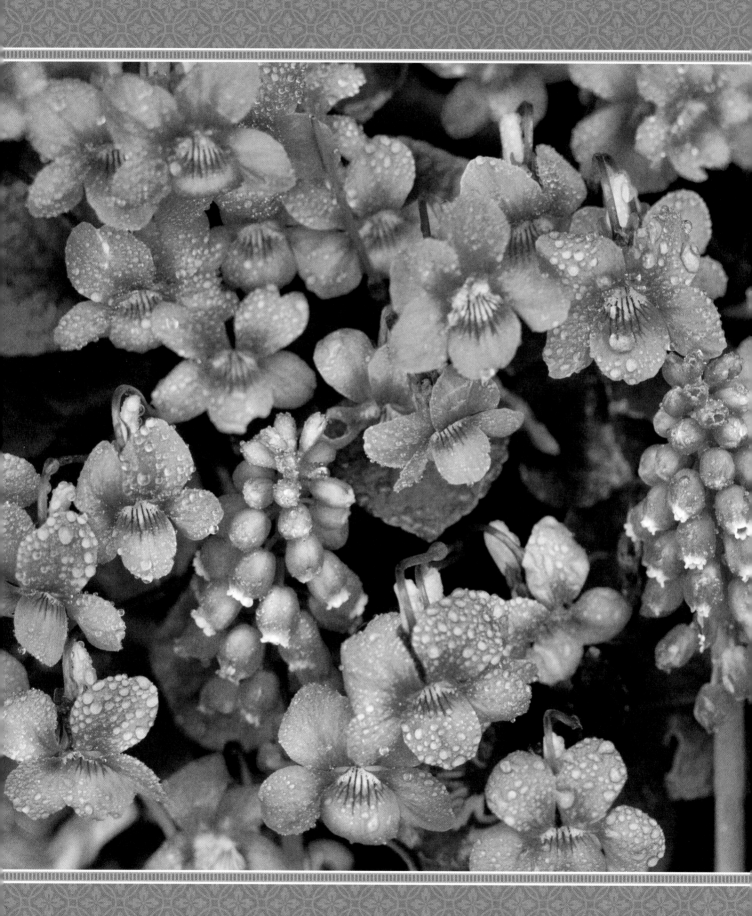

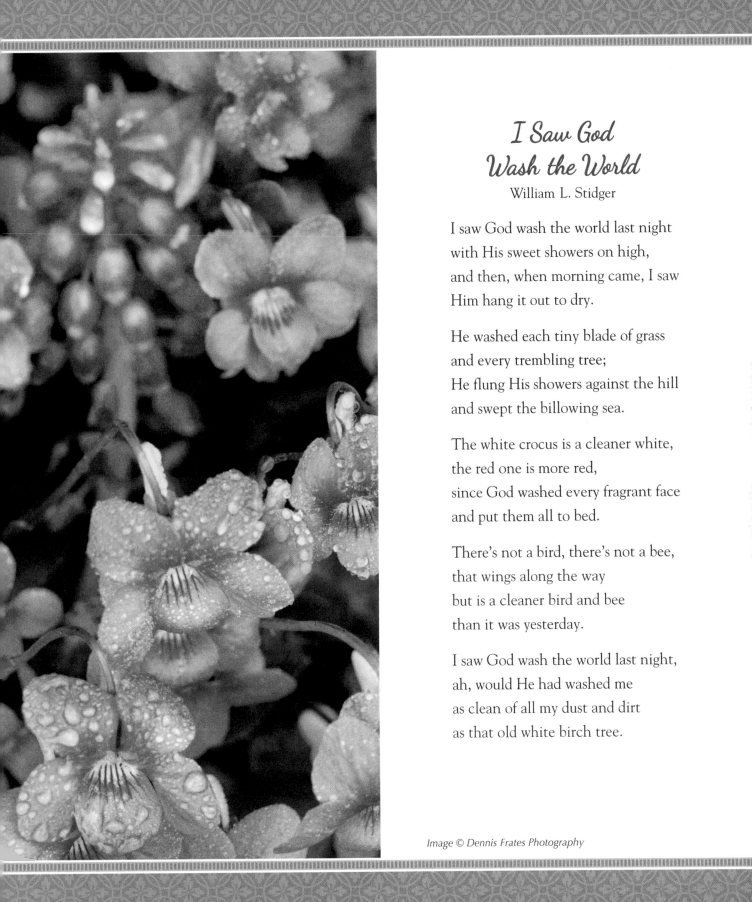

I Saw God
Wash the World
William L. Stidger

I saw God wash the world last night
with His sweet showers on high,
and then, when morning came, I saw
Him hang it out to dry.

He washed each tiny blade of grass
and every trembling tree;
He flung His showers against the hill
and swept the billowing sea.

The white crocus is a cleaner white,
the red one is more red,
since God washed every fragrant face
and put them all to bed.

There's not a bird, there's not a bee,
that wings along the way
but is a cleaner bird and bee
than it was yesterday.

I saw God wash the world last night,
ah, would He had washed me
as clean of all my dust and dirt
as that old white birch tree.

A Student of the Season

Anne Kennedy Brady

My two-year-old is in a "why" phase. Why is that flower red? Why am I wearing that shirt? Why must I wear shoes yet again? It's like living with a tiny Columbo.

The other day a spring thunderstorm rolled through our city; and when I switched on the windshield wipers on the way to ballet class, Helen demanded that I explain my actions.

"Because it's raining, sweetheart," I sighed. Was it really only 9:30 a.m.?

"Why it's rainin'?" she wanted to know.

"Well," I began, "the rain helps plants grow. Without rain we wouldn't have tall trees or pretty flowers—"

"Or puddles!" My five-year-old interjected.

Helen gasped. "I wike puddles!"

"And worms!" Milo continued.

"WORMS!" Helen repeated with gusto.

Her brother proceeded to regale us with as many gross adjectives he could think of to describe worms until we finally disembarked in front of Miss Tutu's Ballet School.

That afternoon, while one child napped and the other listened lazily to an audiobook, I found myself staring at the rain still falling against our windows. I hadn't been wrong. The rain would indeed make the plants grow—on the other side of this oppressive monochrome waited a veritable rainbow of summer flora. But my son was right too. Giant puddles and (squishy, slimy, squirmy) worms were outside right now. By anticipating the lush gardens to come, was I missing treasures found only in the damp gray of early spring?

This isn't a new phenomenon. My kids are always finding things I miss, forcing me to slow down, retrace my steps, stop and look—no, really look, Mom—at that spiderweb, this crayon, his shoelace. Maybe it's our height difference. I'm always looking over their heads—literally. Where are we going? How long will it take to get there? What's in our way? But my children, who are so much closer to the ground, much prefer what's *on* our way. After all, it's hard to ignore the earth's bounty when you're practically eye-level with it! My son will stop every few steps to pick up a rock he's convinced is a "precious gem." My daughter will crouch down in the middle of a crosswalk to watch over a ladybug, because "him is trying to get home!" I hurry them along because that's what moms do—we have to get to lunch or the playdate or naptime or the doctor. But to my kids, wherever they are is a destination in itself. Nothing is more interesting or important than right now.

We all know the things we're supposed to

teach our kids—kindness, resilience, table manners, and on and on. But my kids have been trying to teach me something equally valuable: contentment. And while I'm not always the best student, I think their lessons hit home in springtime. I can spend March through June wishing that summer's languid warmth would hurry up and get here. Or, I can breathe deep and smell the rain. I can worry that my flowers won't bloom. Or I can marvel at how a late frost turns a spiderweb into a work of art. Spring inches forward with promises that require patience, and we can choose either to endure the wait or to enjoy it. In the middle of a steel-gray April, I tend toward reluctant endurance. But my children daily nudge me toward joy.

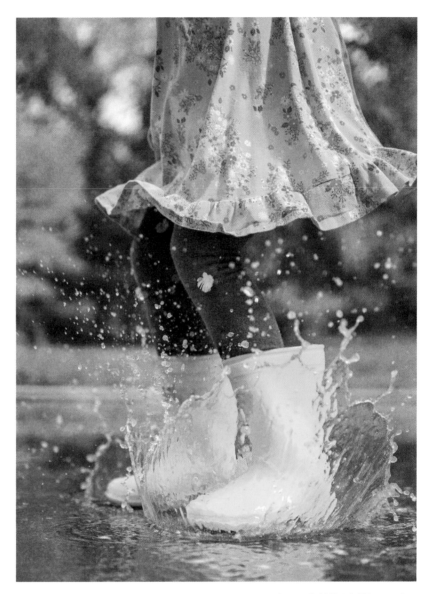

Image © Valio84sl/Dreamstime

I took the kids outside after naptime; and while I shivered under my umbrella, they sped off down the sidewalk. Helen identified the deepest puddle and stomped through it for ten minutes straight, filling her boots with water and squealing with laughter. Milo (to my disgust) dug through sludgy water next to parked cars, presenting me with such priceless discoveries as a sodden mitten, an empty lip balm tube, and a bottle cap. I couldn't help smiling. And when they insisted on a soggy round of hide-and-seek, I happily obliged. Of course, I'll still breathe a sigh of relief when we can exchange our wool hats for swimsuits. But I'm starting to appreciate what treasures the chilly rain has brought today—even if they're as humble as a bottlecap or a worm or two muddy hands in mine as we retreat inside for hot chocolate.

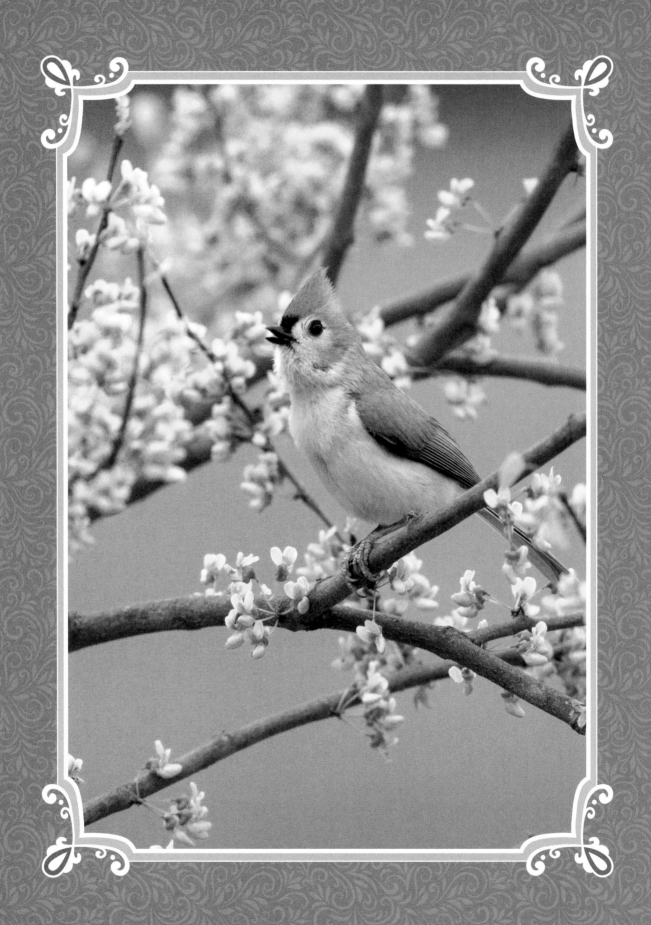

God, the Artist

Angela Morgan

God, when you thought of
 a pine tree,
how did you think of a star?
How did you dream of a
 damson west
crossed by an inky bar?
How did you think of a
 clear brown pool
where flocks of shadows are?

God, when you thought of
 a cobweb,
how did you think of dew?
How did you know a
 spider's house
had shingles, bright and new?
How did you know we
 human folk
would love them as we do?

God, when you patterned
 a birdsong,
flung on a silver string,
how did you know the ecstasy
that crystal call would bring?

How did you think of a
 bubbling throat
and a darling speckled wing?

God, when you chiseled
 a raindrop,
how did you think of a stem
bearing a lovely satin leaf
to hold the tiny gem?
How did you know a
 million drops
would deck the morning's hem?

Why did you make the
 moonlit night
with the honeysuckle vines?
How did you know
 Madeira bloom
distilled ecstatic wines?
How did you weave the
 velvet dusk
where tangled perfumes are?
God, when you thought of
 a pine tree,
how did you think of a star?

Image © Stanley45/iStock

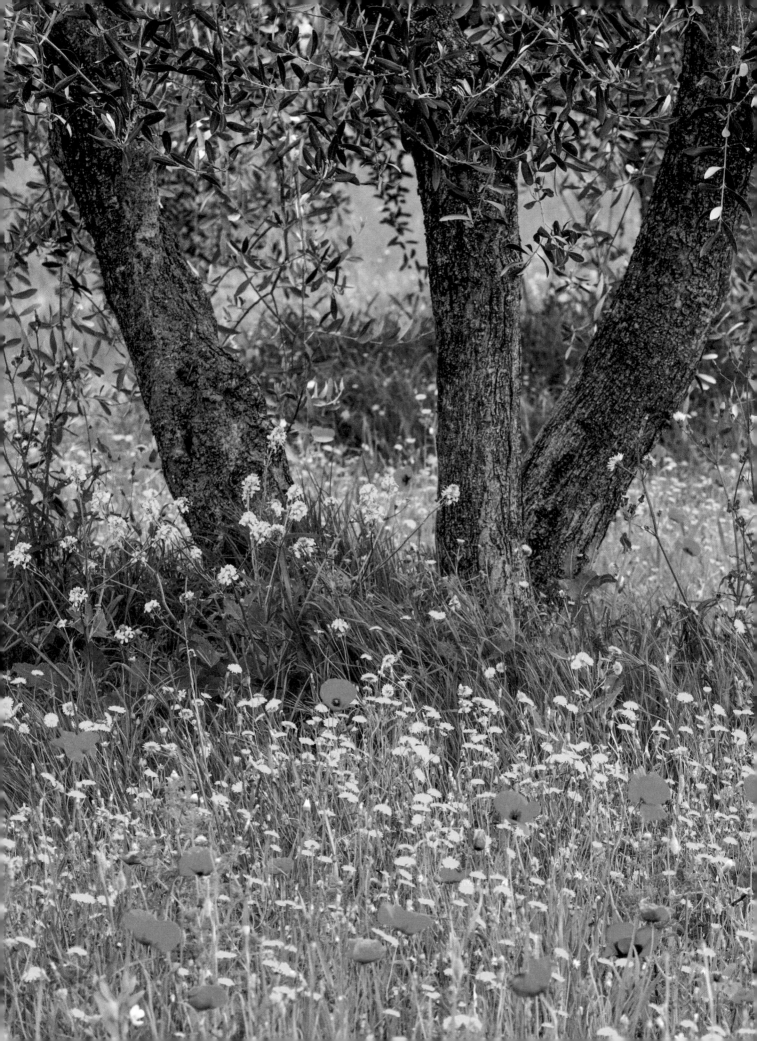

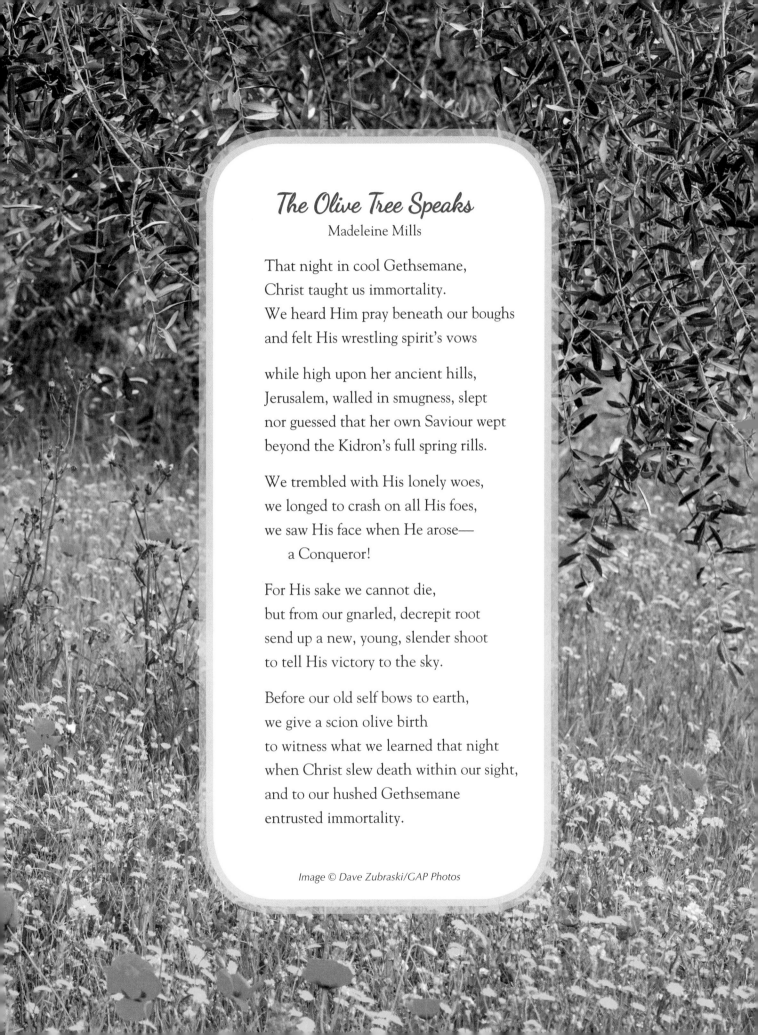

The Olive Tree Speaks

Madeleine Mills

That night in cool Gethsemane,
Christ taught us immortality.
We heard Him pray beneath our boughs
and felt His wrestling spirit's vows

while high upon her ancient hills,
Jerusalem, walled in smugness, slept
nor guessed that her own Saviour wept
beyond the Kidron's full spring rills.

We trembled with His lonely woes,
we longed to crash on all His foes,
we saw His face when He arose—
 a Conqueror!

For His sake we cannot die,
but from our gnarled, decrepit root
send up a new, young, slender shoot
to tell His victory to the sky.

Before our old self bows to earth,
we give a scion olive birth
to witness what we learned that night
when Christ slew death within our sight,
and to our hushed Gethsemane
entrusted immortality.

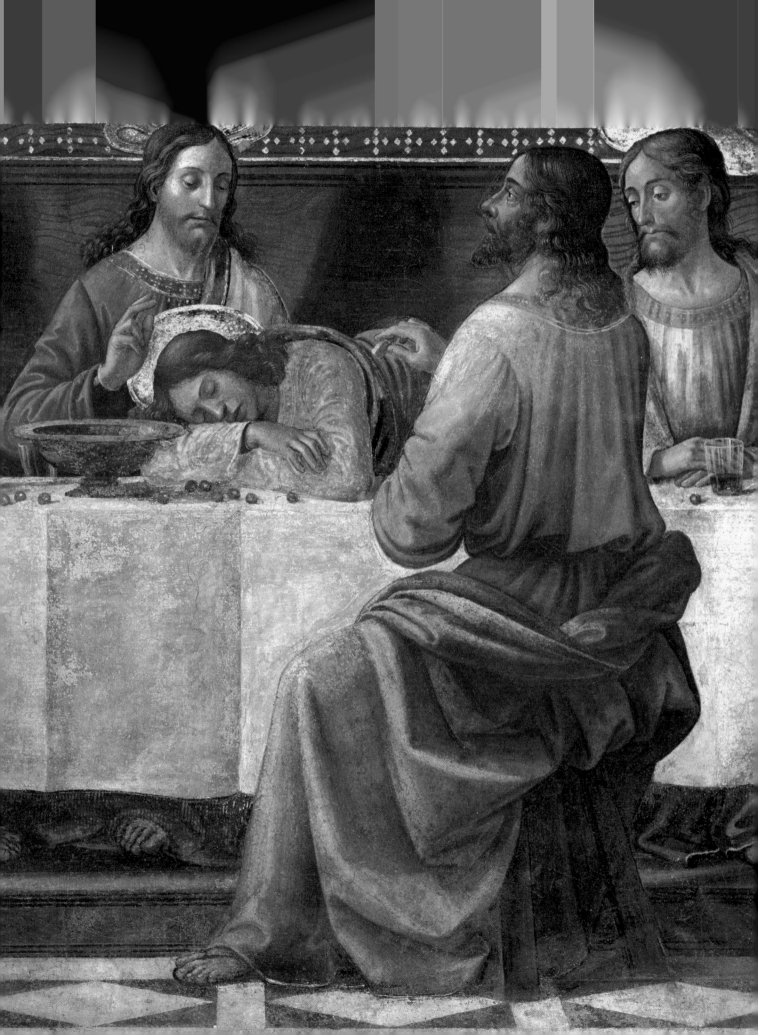

He was despised and rejected by men, a man of sorrows and acquainted with grief.
—Isaiah 53:3

The Betrayal and Arrest

Matthew 26:1–2, 14–16, 20–32, 47

When Jesus had finished all these sayings, he said to his disciples, "You know that after two days the Passover is coming, and the Son of Man will be delivered up to be crucified." . . .

Then one of the twelve, whose name was Judas Iscariot, went to the chief priests and said, "What will you give me if I deliver him over to you?" And they paid him thirty pieces of silver. And from that moment he sought an opportunity to betray him. . . .

When it was evening, he reclined at table with the twelve. And as they were eating, he said, "Truly, I say to you, one of you will betray me." And they were very sorrowful and began to say to him one after another, "Is it I, Lord?" He answered, "He who has dipped his hand in the dish with me will betray me. The Son of Man goes as it is written of him, but woe to that man by whom the Son of Man is betrayed! It would have been better for that man if he had not been born." Judas, who would betray him, answered, "Is it I, Rabbi?" He said to him, "You have said so."

Now as they were eating, Jesus took bread, and after blessing it broke it and gave it to the disciples, and said, "Take, eat; this is my body." And he took a cup, and when he had given thanks he gave it to them, saying, "Drink of it, all of you, for this is my blood of the covenant, which is poured out for many for the forgiveness of sins. I tell you I will not drink again of this fruit of the vine until that day when I drink it new with you in my Father's kingdom."

And when they had sung a hymn, they went out to the Mount of Olives. Then Jesus said to them, "You will all fall away because of me this night. For it is written, 'I will strike the shepherd, and the sheep of the flock will be scattered.' But after I am raised up, I will go before you to Galilee." . . . While he was still speaking, Judas came, one of the twelve, and with him a great crowd with swords and clubs, from the chief priests and the elders of the people.

They have pierced my hands and feet . . . they stare and gloat over me;
they divide my garments among them, and for my clothing they cast lots.
—Psalm 22:16–18

Trial and Crucifixion

Matthew 26:57, 59–60, 62–66; 27:35–37, 45–46, 50–54

Then those who had seized Jesus led him to Caiaphas the high priest, where the scribes and the elders had gathered. . . . Now the chief priests and the whole council were seeking false testimony against Jesus that they might put him to death, but they found none, though many false witnesses came forward. . . . And the high priest stood up and said, "Have you no answer to make? What is it that these men testify against you?" But Jesus remained silent. And the high priest said to him, "I adjure you by the living God, tell us if you are the Christ, the Son of God." Jesus said to him, "You have said so. But I tell you, from now on you will see the Son of Man seated at the right hand of Power and coming on the clouds of heaven." Then the high priest tore his robes and said, "He has uttered blasphemy. What further witnesses do we need? You have now heard his blasphemy. What is your judgment?" They answered, "He deserves death." . . .

And when they had crucified him, they divided his garments among them by casting lots. Then they sat down and kept watch over him there. And over his head they put the charge against him, which read, "This is Jesus, the King of the Jews." . . . Now from the sixth hour there was darkness over all the land until the ninth hour. And about the ninth hour Jesus cried out with a loud voice, saying, "*Eli, Eli, lema sabachthani?*" that is, "My God, my God, why have you forsaken me?" . . . And Jesus cried out again with a loud voice and yielded up his spirit.

And behold, the curtain of the temple was torn in two, from top to bottom. And the earth shook, and the rocks were split. The tombs also were opened. And many bodies of the saints who had fallen asleep were raised, and coming out of the tombs after his resurrection they went into the holy city and appeared to many. When the centurion and those who were with him, keeping watch over Jesus, saw the earthquake and what took place, they were filled with awe and said, "Truly this was the Son of God!"

DEPLORATION OF THE DEAD CHRIST *by Fra Angelico. Image © Nicolo Orsi Battaglini/Bridgeman Images*

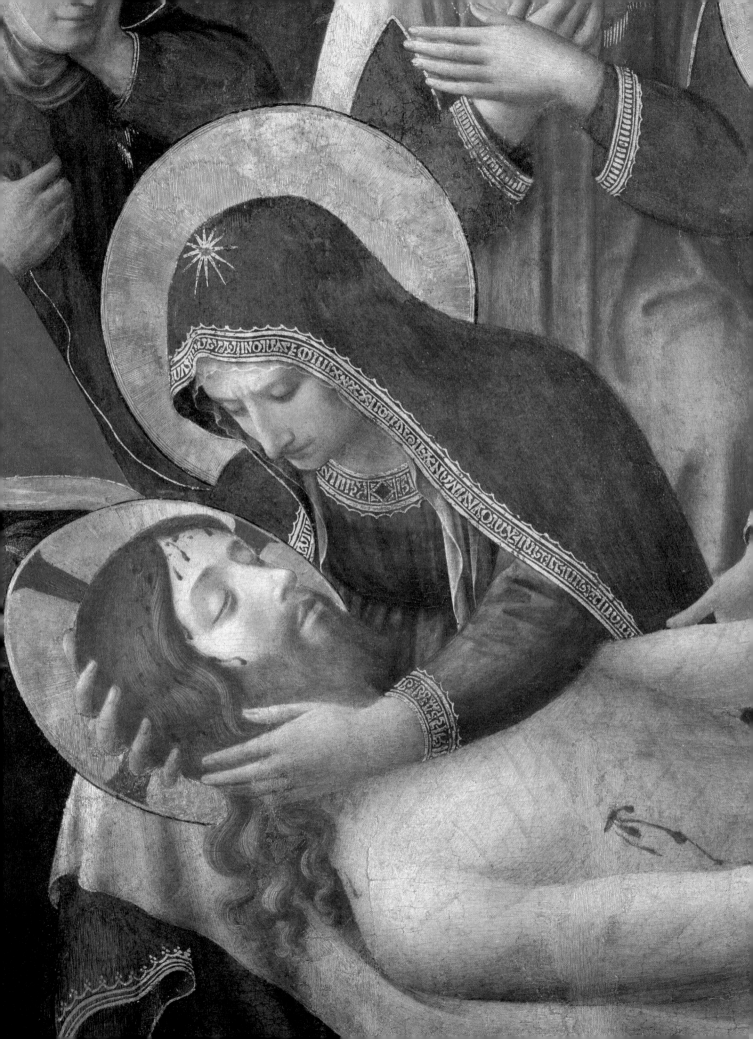

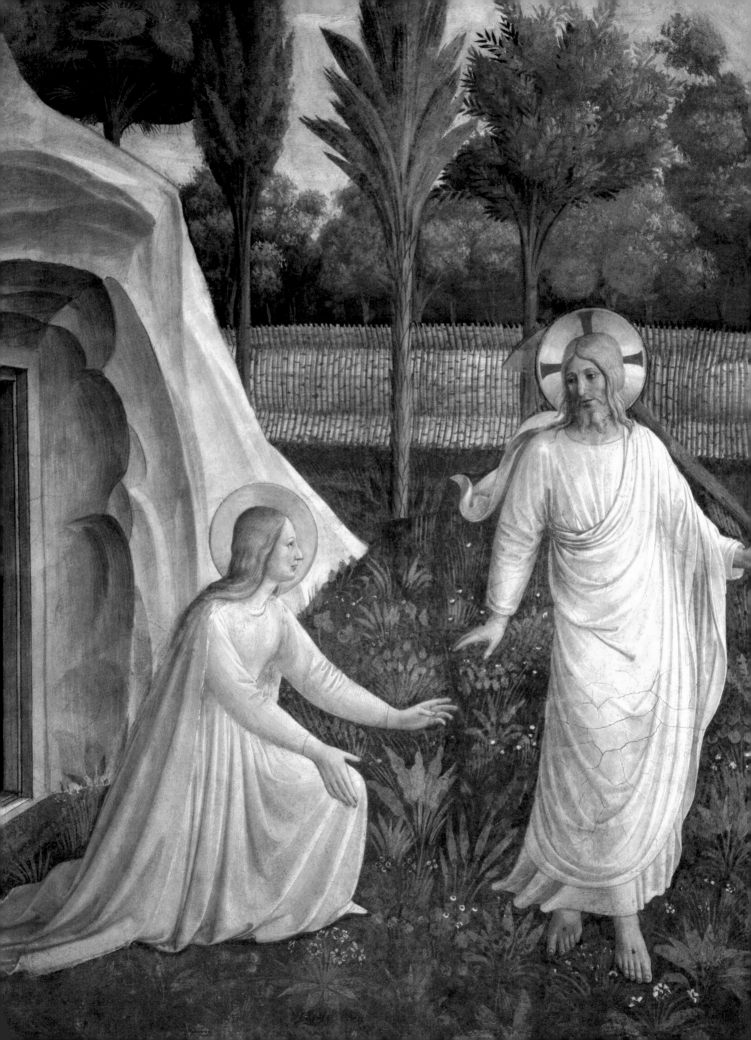

He was pierced for our transgressions; he was crushed for our iniquities;
upon him was the chastisement that brought us peace, and with his wounds we are healed.
—Isaiah 53:5

The Resurrection
Mark 16:1–8; John 20:19–29

When the Sabbath was past, Mary Magdalene, Mary the mother of James, and Salome bought spices, so that they might go and anoint him. And very early on the first day of the week, when the sun had risen, they went to the tomb. And they were saying to one another, "Who will roll away the stone for us from the entrance of the tomb?" And looking up, they saw that the stone had been rolled back—it was very large. And entering the tomb, they saw a young man sitting on the right side, dressed in a white robe, and they were alarmed. And he said to them, "Do not be alarmed. You seek Jesus of Nazareth, who was crucified. He has risen; he is not here. See the place where they laid him. But go, tell his disciples and Peter that he is going before you to Galilee. There you will see him, just as he told you." And they went out and fled from the tomb, for trembling and astonishment had seized them, and they said nothing to anyone, for they were afraid. . . .

On the evening of that day, the first day of the week, the doors being locked where the disciples were for fear of the Jews, Jesus came and stood among them and said to them, "Peace be with you." When he had said this, he showed them his hands and his side. Then the disciples were glad when they saw the Lord.

Now Thomas, one of the twelve, called the Twin, was not with them when Jesus came. So the other disciples told him, "We have seen the Lord." But he said to them, "Unless I see in his hands the mark of the nails, and place my finger into the mark of the nails, and place my hand into his side, I will never believe."

Eight days later, his disciples were inside again, and Thomas was with them. Although the doors were locked, Jesus came and stood among them and said, "Peace be with you." Then he said to Thomas, "Put your finger here, and see my hands; and put out your hand, and place it in my side. Do not disbelieve, but believe." Thomas answered him, "My Lord and my God!" Jesus said to him, "Have you believed because you have seen me? Blessed are those who have not seen and yet have believed."

Noli Me Tangere *by Fra Angelico. Image © Raffaello Bencini/Bridgeman Images*

Sunday Morning Sunrise

Clay Harrison

It was a sunrise like no other
that first Easter morn.
Earth hadn't seen a more joyful day
since Jesus Christ was born.
He appeared to those who loved Him
to prove His word was true.
His disciples' work had just begun
and there was much to do.

On Golgotha stood His
 blood-stained cross,
an empty tomb down below.
An angel rolled the stone away
as the sun began to glow.
For this purpose He was begotten—
to wash our sins away,
asking only that we love Him
and seek His will each day.

He said, "Now it is finished—
your sin debt has been paid!"
He would soon return to heaven,
His Father's will obeyed.
It was a Sunday morning sunrise
that showered earth with love,
as God and all His angels
rejoiced somewhere above!

Warwick, NY. Image © Brian Logan/iStock

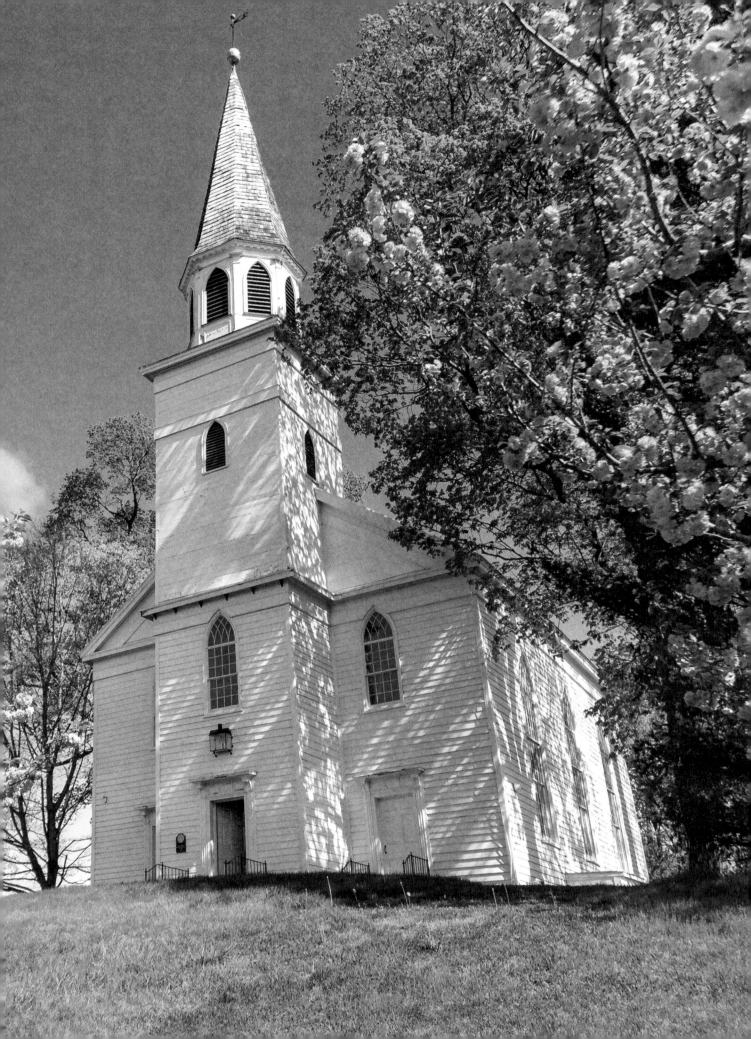

The Holy City

F. E. Weatherly

Last night as I lay sleeping, there came a dream so fair;
I stood in old Jerusalem beside the temple there.
I heard the children singing and ever as they sang,
me thought the voice of angels from heav'n in answer rang;
me thought the voice of angels from heav'n in answer rang.

Jerusalem! Jerusalem! Lift up your gates and sing.
Hosanna in the highest! Hosanna to your King!

And then me thought my dream was changed;
 the streets no longer rang.
Hushed were the glad hosannas the little children sang.
The sun grew dark with mystery, the morn was cold and chill,
as the shadow of the cross arose upon a lonely hill.
As the shadow of the cross arose upon a lonely hill.

Jerusalem! Jerusalem! Hark how the angels sing
Hosanna in the highest! Hosanna to your King!

And once again the scene was changed,
 new earth there seemed to be.
I saw the Holy City beside the tideless sea.
The light of God was on the streets, the gates were open wide,
and all who would might enter there, and no one was denied.
No need of moon or stars by night or sun to shine by day;
it was the new Jerusalem that would not pass away.
It was the new Jerusalem that would not pass away.

Jerusalem! Jerusalem! Sing for the night is o'er!
Hosanna in the highest! Hosanna evermore!
Hosanna in the highest! Hosanna evermore!

The Story of "The Holy City"

Pamela Kennedy

This majestic hymn was written in 1892 by Frederic Weatherly, successful English lawyer, author, and prodigious lyricist. Although Weatherly composed over three thousand songs, only three are still well-known: "Danny Boy," "Roses of Picardy," and "The Holy City." While his contemporary critics disparaged his lyrics as being overly sentimental and lacking artistic excellence, his hymn, "The Holy City," has survived as a powerful and inspiring Easter anthem. Its three short verses trace, through the vehicle of a dream, both biblical history and prophecy linking Jesus Christ with Jerusalem.

The first verse recalls Christ's entry into Jerusalem on Palm Sunday, accompanied by the songs and praises of children. The second, adopting a somber tone, describes the crucifixion of Christ, on Good Friday. Then, in the triumphant third verse, Weatherly anticipates the new Jerusalem prophesied by John in chapter 21 of the book of Revelation:

"Then I saw a new heaven and a new earth, for the first heaven and the first earth had passed away; and I saw the Holy City, the new Jerusalem, coming down out of heaven from God, prepared as a bride beautifully dressed for her husband . . . The city does not need the sun or the moon to shine on it, for the glory of God gives it light, and the Lamb is its lamp" (Rev. 21:1–2, 23, NIV).

Weatherly concludes each verse with a joyous chorus echoing the praises of the crowds on Palm Sunday, expressing gratitude for Christ's sacrifice, and anticipating His triumphant return—"Hosanna, hosanna in the highest! Hosanna evermore!"

Image © David San Segundo/AdobeStock

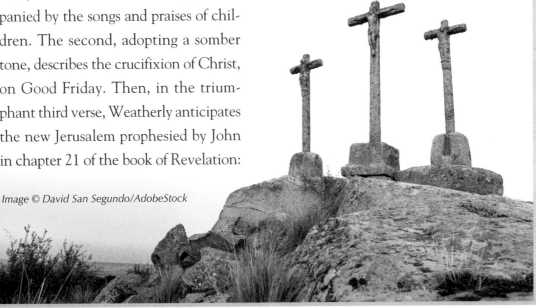

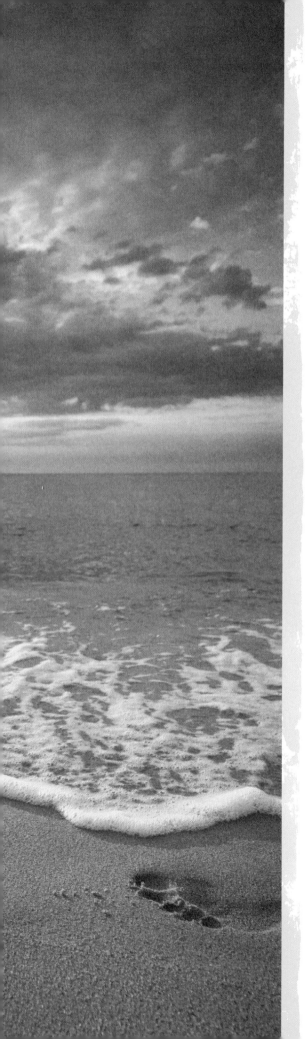

The Coming of His Feet
Lyman W. Allen

In the crimson of the morning, in the whiteness
 of the noon,
in the amber glory of the day's retreat,
in the midnight, robed in darkness, or the gleaming
 of the moon,
I listen to the coming of His feet.

I heard His weary footsteps on the sands of Galilee,
on the Temple's marble pavement, on the street,
worn with weight of sorrow, faltering up the slopes
 of Calvary,
the sorrow of the coming of His feet.

Down the minster aisles of splendor, from betwixt
 the cherubim,
through the wondering throng, with motion
 strong and fleet,
sounds His victor tread approaching, with a music
 far and dim;
the music of the coming of His feet.

Sandaled not with sheen of silver, girded not
 with woven gold,
weighted not with shimmering gems
 and odors sweet,
but white-winged and shod with glory in the
 Tabor light of old;
the glory of the coming of His feet.

He is coming, O my spirit, with His
 everlasting peace,
with His blessedness immortal and complete;
He is coming, O my spirit, and His coming
 brings release;
I listen for the coming of His feet.

Bits & Pieces

How sweet the name of Jesus sounds, in a believer's ear! It soothes his sorrows, heals his wounds, and drives away his fear.
—*John Newton*

And he said to them, "Do not be alarmed. You seek Jesus of Nazareth, who was crucified. He has risen; he is not here. See the place where they laid him."
—*Mark 16:6*

Jesus took the tree of death so we could have the tree of life.
—*Tim Keller*

Do not abandon yourselves to despair. We are the Easter people and hallelujah is our song.
—*Pope John Paul II*

The death and the burial and the Resurrection of Jesus happened over three days. Friday was the day of suffering and pain and agony. Saturday was the day of doubt and confusion and misery. But Easter, that Sunday, was the day of hope and joy and victory.
—*Rick Warren*

Christ the Lord is risen. Our joy that hath no end.
—*John of Damascus*

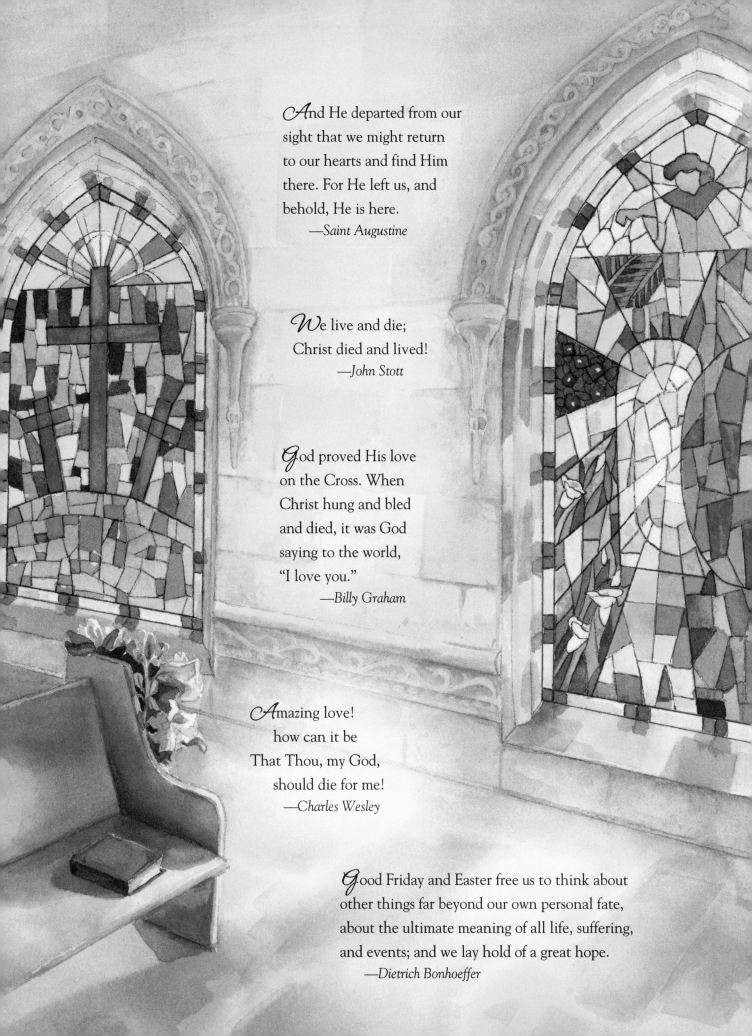

And He departed from our sight that we might return to our hearts and find Him there. For He left us, and behold, He is here.
—*Saint Augustine*

We live and die;
Christ died and lived!
—*John Stott*

God proved His love on the Cross. When Christ hung and bled and died, it was God saying to the world, "I love you."
—*Billy Graham*

Amazing love!
how can it be
That Thou, my God,
should die for me!
—*Charles Wesley*

Good Friday and Easter free us to think about other things far beyond our own personal fate, about the ultimate meaning of all life, suffering, and events; and we lay hold of a great hope.
—*Dietrich Bonhoeffer*

Easter in Kentucky

Andrew L. Luna

*T*here are few places more beautiful than Kentucky during the springtime. As winter's thaw yields to burgeoning bud and bloom, a sweet freshness fills the air, while songbirds arrive from more southern regions and fill the mornings with soft music. Everywhere there are contrasts. The gray-white limestone jutting from cliffs and overhangs are accented against the lush green grasses of Kentucky blue and fescue. The welcoming fuchsia-colored redbuds popping out to meet the warm sunlight distinguish themselves next to the soft pink and white of the dogwoods and the unfurling green leaves of oak and elm. Sprinkled among all of this beauty are the rich colors of daffodils, asters, and crocuses.

Taking an early drive along a Kentucky countryside during spring, I am rewarded with many treasures. As the morning mist gently rises over field and meadow, the first wildflowers of the year come alive next to the expanse of white and dark fencing along the roadside. Cattle graze on the delicate, moist meadowlands while a small heifer bellows for her mother, breaking the stillness and calmness in the cool morning air.

Along the countryside are dark-colored tobacco barns that have been worn and weathered with the ebb and tide of the seasons. Tobacco barns are always painted black or some other dark color in order to absorb heat from the sun, which helps cure the tobacco leaves hanging inside. Many of these barns have faded signs painted on them bidding the traveler of long ago to "See Rock City," "Chew Pouch Tobacco," or "Maxwell House Coffee Is Good to the Last Drop."

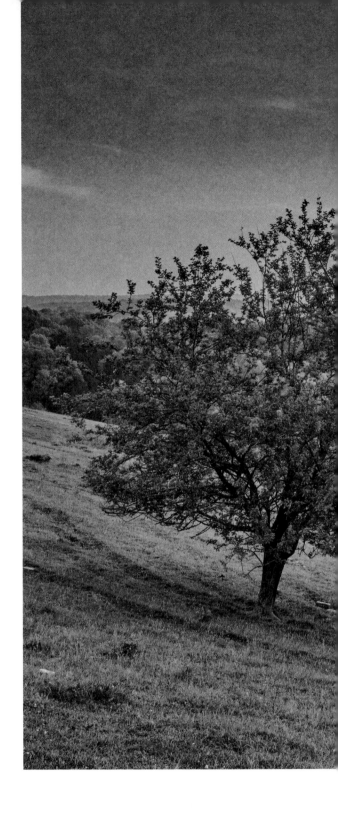

Looking over to another field, I see an Arabian foal and mare running through a yellow carpet of buttercups under a rich, deep blue sky dotted with fluffy, white clouds while, in the yards of old farmhouses, wild grape hyacinths boast their purple color alongside the rich gold of blooming forsythia. Purple and pink tulips stand

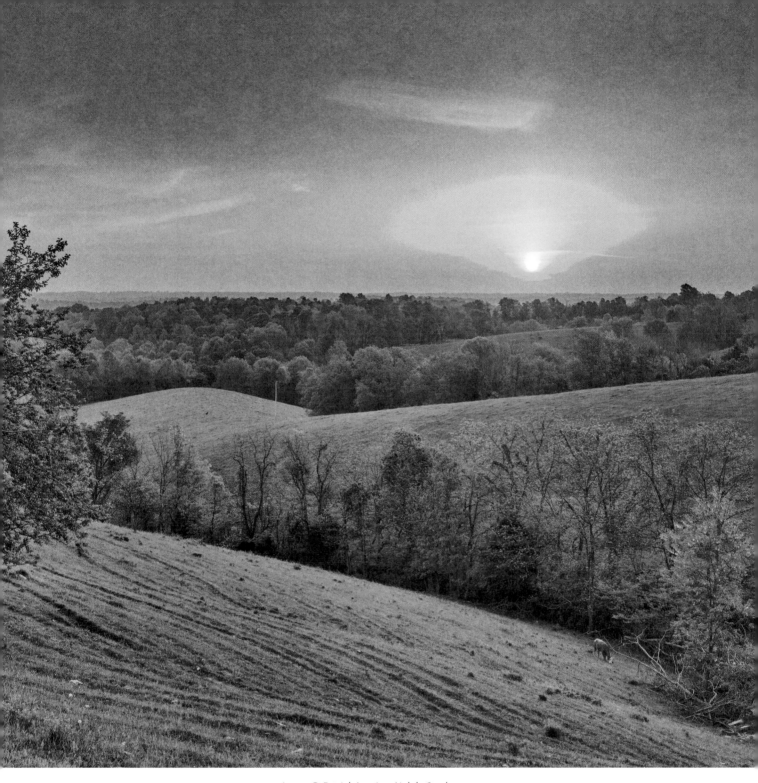

Image © Patrick Jennings/AdobeStock

tall and rigid against the morning's gentle breeze.

In Kentucky, the signs of spring and the coming of Easter are noticeable and poignant. Churches all over Kentucky are awash with color, not only from nature's springtime bounty, but from all of the congregants dressed in their bright Easter best. People greet each other warmly in the golden sunlight of a new day. Church bells peal through the cool morning air as the muffled sounds of organs are heard from inside sanctuaries decorated with white Easter lilies. Kentucky, like nature itself, sleeps during the cold and gloom of winter; but it awakens with the arrival of spring and the promise of Easter.

God Bless You

Author Unknown

I seek in prayerful words, dear friend,
my heart's true wish to send you,
that you may know that, far or near,
my loving thoughts attend you.

I cannot find a truer word,
nor better to address you;
nor song, nor poem have I heard
is sweeter than "God bless you!"

God bless you! So I've wished you all
of brightness life possesses;
for can there any joy at all
be yours unless God blesses?

And so, through all thy days
may shadows touch thee never,
but this alone, God bless thee,
then art thou safe forever.

There Is Always a Place for You

Anne Campbell

There is always a place for you at my table;
you never need be invited.
I'll share every crust as long as I'm able,
and know you will be delighted.
There is always a place for you by my fire;
and though it may burn to embers,
if warmth and good cheer are your desire,
the friend of your heart remembers!
There is always a place for you by my side,
and should the years tear us apart,
I will face lonely moments more satisfied
with a place for you in my heart!

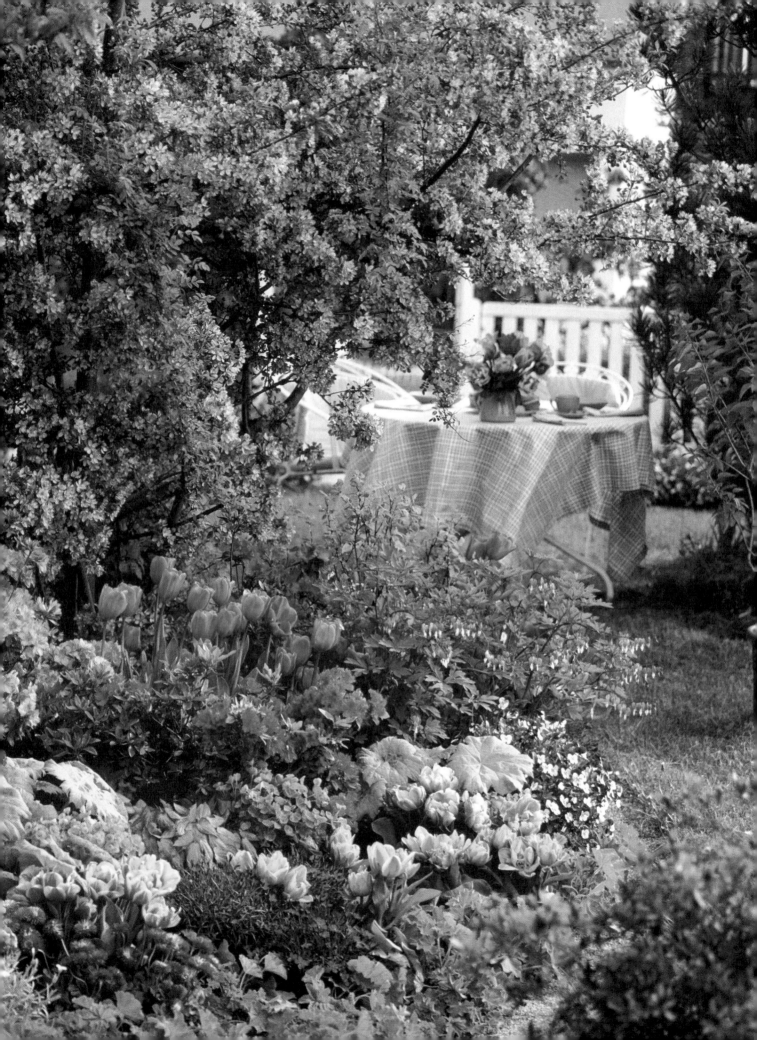

Through My Window

Easter Dinner

Pamela Kennedy

I come from a small family. My childhood holiday dinners often just included my dad, my mom, and me in our tidy little house. Sometimes an aunt and uncle joined us, or a cousin or two. But even then, things were pretty simple. My childhood friend Doris, however, had four siblings and lived in a big farmhouse with porches, an upstairs, and a goodly supply of relatives at holiday time. I always envied her.

We are now both grandmothers, and Doris has dozens of nieces and nephews and in-laws. She recalls her childhood holiday meals as hectic affairs served on plastic dinnerware. So when she had her own family, Doris determined to have the kind of fancy holiday dinners she had always dreamed of. Thus, last Easter, when I invited our son, daughter-in-law, and two grandchildren for Easter dinner, I decided to ramp up my game. I called Doris for some pointers.

We had a lovely chat about celebrating with family, and then she said she'd send me a few photos of her Easter dinner tables from years past. Let me just say that I got more than I bargained for. Doris sets her Easter table with a pastel yellow tablecloth and platinum-trimmed Lenox plates. She has a collection of vintage egg cups, one for each guest, filled with green grass and a gourmet chocolate egg. Foil-wrapped chocolate bunnies and bright chicks filled with jellybeans also grace each place setting. The centerpiece features clusters of roses spilling from several hand-painted ceramic rabbits. Sparkling cider shimmers in stemmed crystal. Her menu includes ham and creamed potatoes, fresh vegetables, and fruit. Homemade bread—one year in the shape of a rabbit—accompanies the meal. There's an Easter cake for dessert, decorated with pastel frosting and a parade of small chocolate rabbits. She said she tried a cake carved and frosted to look like a giant marshmallow Peep one year, "but it was just too much work!" I was exhausted just looking at the photos of her magazine-worthy table. And then I spotted the butter sculptures.

I called Doris. "Are you kidding me? Please tell me you didn't carve those rabbits out of butter!"

"Of course not," she replied with a laugh. "You can get those at the grocery store, dairy aisle. Do you think I'm nuts?" I just sighed.

I decided to go for something between my dear friend's extravagant artistry and my minimalist heritage. Our grandchildren were nine and six, and I wanted them to have some sweet memories of Easter dinner at Grammy and Papa's.

At a local resale shop I nabbed an assortment of little woodland creatures to tuck in between the votive lights down the center of the table.

My moss green tablecloth made a nice background for Grandma's floral Spode dishes, and I was off and running with my spring motif! I thought it would be fun for the kids to take part in some of the preparations, so I searched online and stumbled upon a tutorial for folding cloth napkins to look like rabbits. Perfect for nine-year-old Henry who loves origami! At a craft store I found some small cupcake holders that resembled baskets. I bought a bag of speckled jellybeans and some plastic grass. The six-year-old could use her elementary math skills to distribute an equal number of jelly beans into each little basket. I adopted my friend's menu almost verbatim but opted for an easier dessert— scoops of ice cream sprinkled with green-tinted coconut and topped with small candy Easter eggs. And when I was in the dairy aisle, I picked up something special.

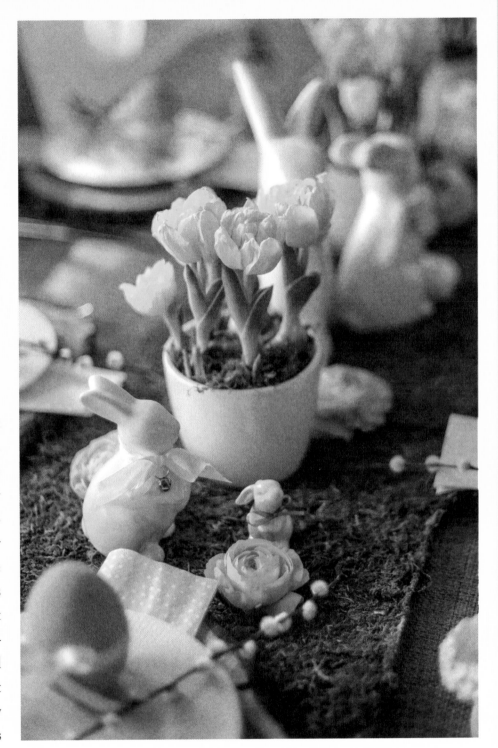

Image © Asmfoto/Dreamstime

As we gathered around the Easter table, we held hands and my husband said the blessing. I raised my eyes to see the smiles of the family. My grandchildren proudly pointed out their contributions to the table. The conversation swirled as we shared the fragrant ham and passed the store-bought rolls. Then my granddaughter Evelyn exclaimed with wonder, "Hey, check this out, everyone! I just buttered my roll with the back end of the bunny!" Doris would have been proud!

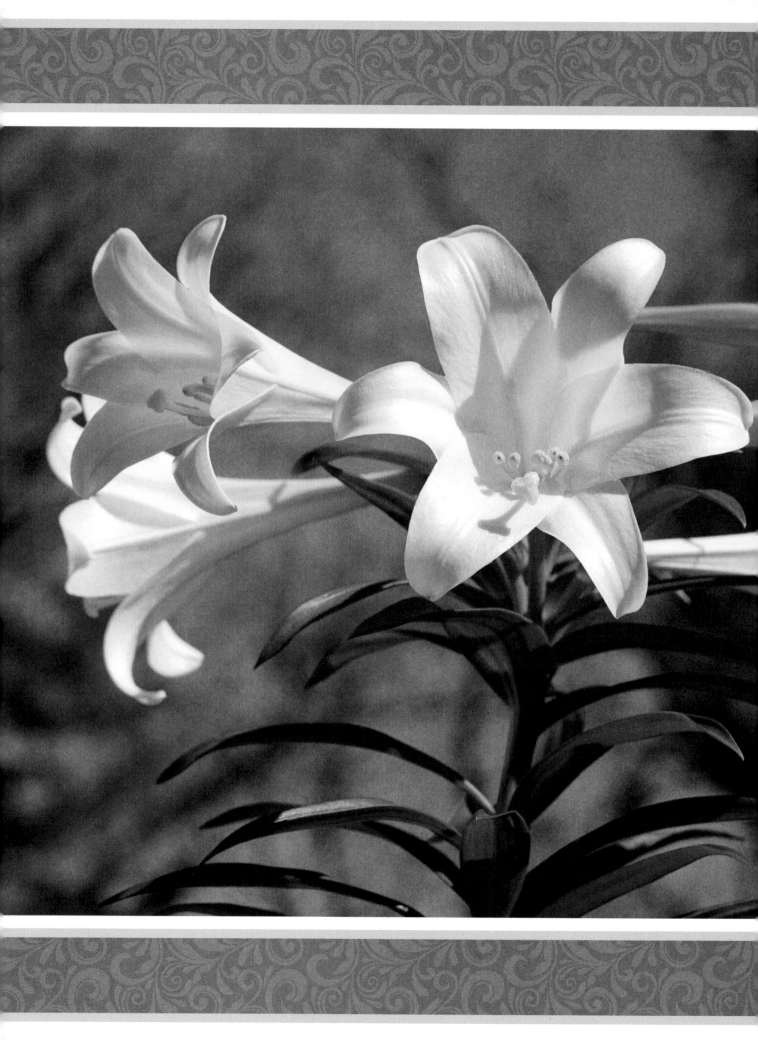

Easter Grace

Peter Marshall

*L*ord Jesus, may we never again think and act as if Thou wert dead. Let us more and more come to know Thee as a living Lord who hath promised to them that believe: "Because I live, ye shall live also."

Help us to remember that we are praying to the Conquerer of Death, that we may no longer be afraid nor be dismayed by the world's problems and threats, since Thou hast overcome the world. In Thy strong name, we ask for Thy living presence and Thy victorious power; amen.

An Easter Prayer

Saint Thomas Aquinas

*G*ive us, O Lord, a steadfast heart, which no unworthy affection may drag down; give us an unconquered heart, which no tribulation can wear out; give us an upright heart, which no unworthy purpose may tempt aside.

Bestow upon us also, O Lord our God, understanding to know Thee, diligence to seek Thee, wisdom to find Thee, and a faithfulness that may finally embrace Thee, even through Jesus Christ our Lord. Amen.

Family Recipes

Creamy Spiced Carrot Soup

3 tablespoons olive oil	2 orange peel strips
1 cup chopped onion	¾ teaspoon salt
2 stalks celery, chopped	¼ teaspoon black pepper
3 cloves garlic, minced	½ teaspoon ground cinnamon
2 pounds carrots, peeled and chopped	¼ teaspoon ground cloves
4 cups chicken broth	1 cup heavy cream
1 bay leaf	Parmesan cheese, optional

In a Dutch oven, heat oil over medium-high heat. Add onions and celery; sauté until softened. Add garlic; cook about 5 minutes. Add carrots; cook 8 minutes, stirring occasionally, or until carrots are soft. Add chicken broth, bay leaf, orange peel strips, salt, pepper, cinnamon, and cloves. Bring to a boil; cover and reduce heat. Simmer 10 minutes, stirring occasionally. Turn off heat. Remove bay leaf and orange peel; fold in heavy cream. Use an immersion blender to puree or pour soup into blender in small batches and puree until smooth. Ladle into bowls and sprinkle with grated Parmesan cheese, if desired. Makes 6 servings.

Frozen Yogurt Berry Bites

½ pint fresh raspberries	2 tablespoons honey
½ pint fresh blueberries	1 cup loose granola
1½ cups Greek-style yogurt	

Transfer berries to a large mixing bowl. Mash with a potato masher. Fold in yogurt and honey until well combined. Sprinkle 2 teaspoons granola into each cup of mini muffin tin. Spoon yogurt mixture over granola only to the top of the cups. Freeze 4 to 5 hours, or overnight. Remove from muffin cups. Makes 24 yogurt berry bites.

Cream Cheese Carrot Cake Muffins

¾ cup granulated sugar, divided
1 8-ounce package cream cheese,
 room temperature
2 large eggs
¾ cup water
⅓ cup vegetable oil
2¼ cups flour
¼ cup light brown sugar, packed

1½ teaspoons baking powder
1½ teaspoons ground cinnamon
¾ teaspoon ground ginger
¾ teaspoon salt
¼ teaspoon baking soda
1 cup grated carrots (about 2
 medium-large carrots)

Preheat oven to 400°F. Lightly grease a 12-cup muffin pan. In a small bowl, cream ¼ cup granulated sugar and cream cheese; set aside. In a medium bowl, whisk together eggs, water, and oil; set aside. In a large bowl, whisk together ½ cup sugar and remaining dry ingredients. Stir wet ingredients into dry ingredients. Fold in grated carrots, stirring to combine. Drop 2 tablespoons batter into each muffin cup, spreading batter to cover the bottom. Drop one heaping tablespoon of cream cheese mixture in center of each muffin cup, pressing down slightly. Add batter to fill almost to top. (Some batter will be left over.) Bake until a toothpick inserted into the cake part (not cream cheese filling) comes out clean, about 20 minutes. The tops of the muffins will feel firm to the touch. Turn out the muffins on a rack to cool. Caution: filling will be very hot and runny until the muffins cool. Makes 12 muffins.

Egg Salad Sandwiches

¼ cup mayonnaise
1 teapoon lemon juice
1 tablespoon yellow mustard
¼ teaspoon salt
¼ teaspoon pepper
6 large hard-boiled eggs,
 peeled and chopped

½ cup chopped celery
¼ cup sliced green onion
8 slices rustic wheat bread
4 lettuce leaves
4 tomato slices

In a medium bowl, combine mayonnaise, lemon juice, mustard, salt, and pepper. Add chopped eggs, celery, and green onion; mix well. Cover and refrigerate 1 hour. Serve on wheat bread with lettuce and tomato. Makes 4 sandwiches.

Easter at Stillmeadow

Gladys Taber

Easter always comes as a surprise to me, even though the date is clearly marked on my calendar. In our family we have never bothered with flowery Easter bonnets or new spring clothes in fashionable pastels. And we don't have the traditional pot of white lilies, which I dislike because they look so stiff in their formal satin and because their perfume is overpowering. But we do have snowdrops and a few early violets on the table, and the house smells of vinegar after the children have been dyeing eggs and also of chocolate when the hidden baskets are found early in the morning. By midday there is also the rich fragrance of roast lamb or a rosy Virginia ham.

For me, Easter is a shining day. Here in New England it is also apt to be a day of chill winds and mud and gray skies, if not an actual downpour. Every so often it snows on Easter and the children wear mittens when they go outside to hunt for eggs under the lilac bushes. But still it is the brightest day of the year for me, and many people must share my view because the little white church in the village is always full.

After the service we come home and change back into our country corduroys. I put the roast in the oven and then there is time for a short walk up the hill to the old orchard. The hazel bushes are budding and I see that the first green tips of Jill's daffodils are showing on the bank above the pond.

The seasons change but new life is always coming, and in the country one never looks backward. As soon as the crops are harvested, we begin to plan next year's garden. When the rose is faded, there is pruning to do for another lovelier rose. Moments of sadness when the delicate amethyst and ivory lace of the lilacs die may shake the heart, but the next morning we go out to the border and see the rosy red peony, like an English country maid in a lyric, spreading a full skirt.

As I sit for a moment on my favorite granite boulder, I think back over the past year and all the things that have happened, all the days that have made up life here at Stillmeadow. And not only life, for in my heart, too, is a goodly portion of death. The death of those dear to me, and the death of the loved companions who looked at life from the eyes of a dog or cat.

And not being a wise woman, I do not know why I am alive up here on the hill smelling the faint sweet tang of apple leaves and the soft damp odor of the ferns. But this I know. There is something in the world of new beauty, of loveliness, and of grace. There is the meaning of Stillmeadow,

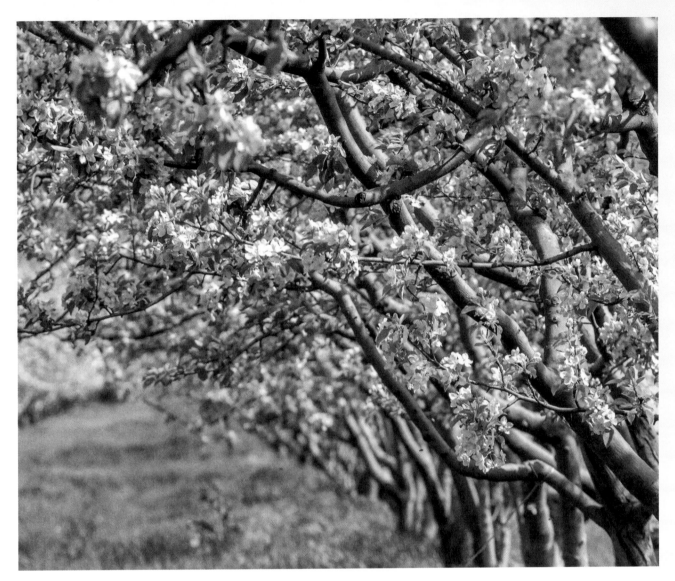

Image © K Samurkas/AdobeStock

deep under the external, and a meaning that will go on down the deep ways of time.

There is the moment of immortality, and this moment is tangible in the first cool crocus sturdy over a froth of snow, in the dark purple of the first glossy globe of the eggplant, and in the slow fall of the first red leaf against the breast of the autumn wind.

And after a little while, alone in the upper orchard, I know that there is a God, and that we, his smallest creatures, do have a meaning somehow, even if we do not know why, and that love is the real and the tangible, but the rest may be a shadow in the sun and cannot endure.

So I go down to my world again, walking through sweet fern.

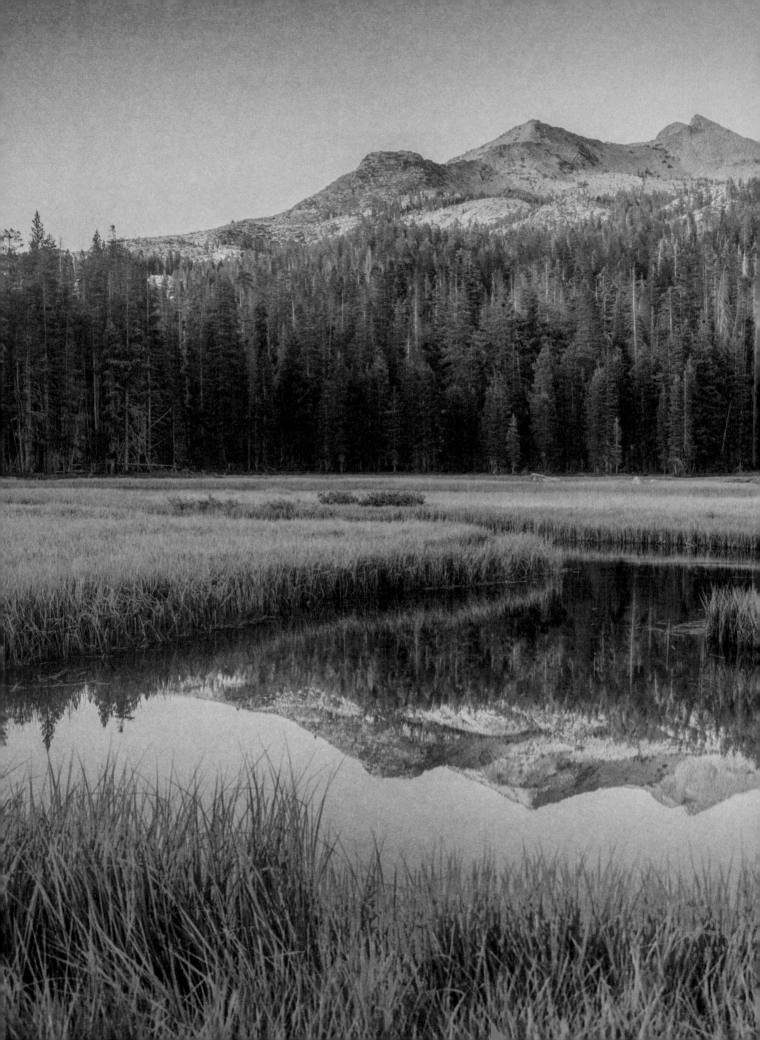

A Day of Sunshine

Henry Wadsworth Longfellow

O gift of God! O perfect day:
whereon shall no man work, but play;
whereon it is enough for me,
not to be doing, but to be!

Through every fiber of my brain,
through every nerve, through every vein,
I feel the electric thrill, the touch
of life, that seems almost too much.

I hear the wind among the trees
playing celestial symphonies;
I see the branches downward bent,
like keys of some great instrument.

And over me unrolls on high
the splendid scenery of the sky,
where through a sapphire sea the sun
sails like a golden galleon . . .

O life and love! O happy throng
of thoughts, whose only speech is song!
O heart of man! canst thou not be
blithe as the air is and as free?

God's World

Edna St. Vincent Millay

O world, I cannot hold
 thee close enough!
Thy winds, thy wide gray skies!
thy mists, that roll and rise!
World, world, I cannot get
 thee close enough!
Long have I known a glory
 in it all,

but never knew I this;
here such a passion is
as stretcheth me apart—
Lord, I do fear
Thou'st made the world
 too beautiful this year!

Wrights Lake near lake Tahoe. Image © Ron and Patty Thomas/iStock

Easter Daffodils

Amannda Gail Maphies

Several years ago, on an eighty-acre plot of land outside of Willard, Missouri, my family would gather around my grandparents' bigger-than-life oak dining table for our annual Easter meal. Stories were told. Updates were shared. Laughter was a requirement, as was a sense of humor, a small helping of political debate, a slightly larger helping of biblical knowledge, and the biggest serving of love. And there was always delicious food, as well.

After eating a scrumptious meal, transitioning from the dining room to the living room for dessert or a short nap, my grandpa would fire up the crackin' and poppin' "Johnny Boy," as we lovingly referred to his beloved green-and-yellow John Deere tractor, which received nearly as much affection as the family dog.

Typically, Grandpa would have a flatbed trailer hooked up to the tractor. After we all piled on, he would jostle the whole family from the barn to the back field. When I was a child, I was often invited to help steer the tractor. Nestled on Grandpa's lap, I felt like a cross between a farm girl and a princess, long blonde ponytail whipping in the wind and doubling as my crown.

In later years, we would rally the family, including the dogs, and enjoy the slight chill of early spring as we trundled along in the trailer. While the route may have varied over the years, the destination was always the same, to the "back forty" where two patches of dadffodils were separated by one of my grandparent's ponds.

My grandmother, aunt, mother, and I all proceeded to pick bundles of daffodils. They were glorious and cheerful and represented everything that still rings true in my heart, when thoughts of spring, Easter, resurrection, newness of life, longer days, and rejuvenation spring forth.

Each of us took bright flower bundles to our own home and arranged them in cheerful vases to adorn the kitchen or living room tables for several days before they began to wilt. Today, just the sight of brilliant yellow daffodils, which faithfully bloom every spring, brings back a flood of memories of my grandparents and those chilly early spring days when we all piled on for the bumpy Easter ride behind "Johnny Boy."

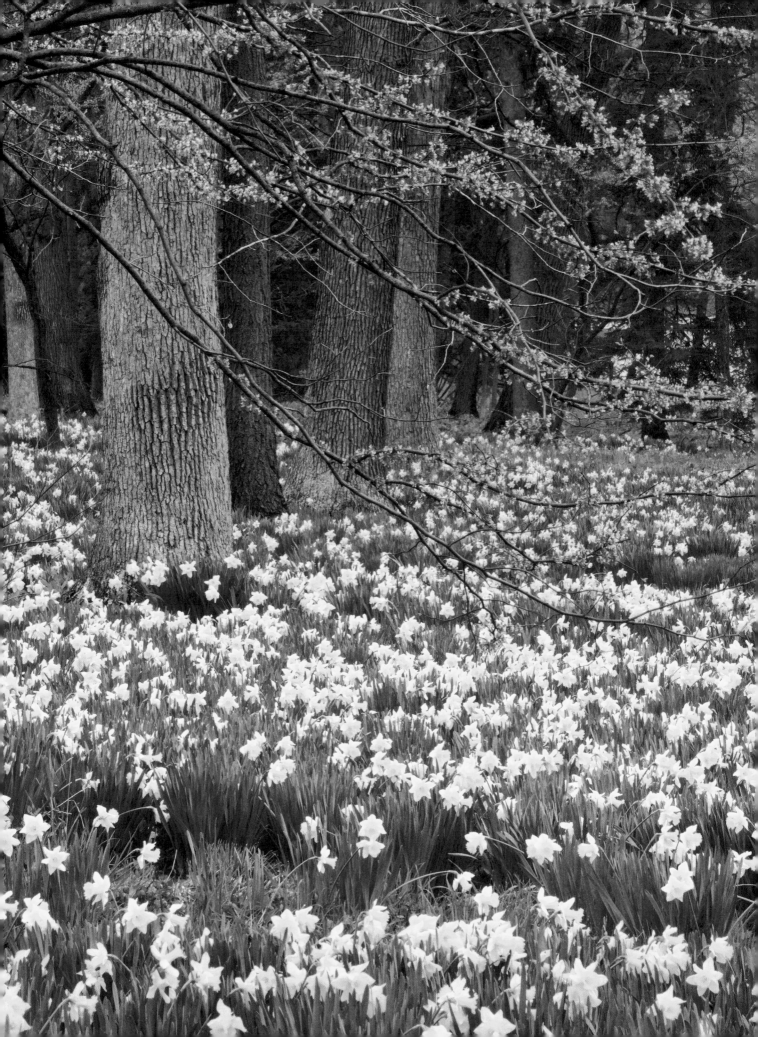

Easter Day Fun
Rebecca Barlow Jordan

Nothing draws a smile
like the joy of Easter day,
when children start to gather
as they run to hide and play.
Their colorful Easter baskets
are bouncing up and down,
as bits of colored grasses drop,
falling to the ground.

Children stop to count their treasures:
candy, yellow and blue,
red and orange and chocolate brown,
there's pink and purple too;
toys and books, so many treats
to keep them occupied.

And when they've eaten all they want,
there are colored eggs to hide.
As the day begins to fade away,
with calm and relaxation,
we thank the Lord for giving us
this happy celebration.

Egg Hunt Time
Pamela Love

"Now's the time to hunt
 for eggs!
All children, gather round.
Take a basket with you
to carry what you've found."
Off they go a-running
as they start to search.
Is that a pink egg by that oak?
A blue one by that birch?

Shouts of joy and laughter
when the eggs they see;
their eager fingers grab them;
then they race to other trees.
At last the hunt is over;
we take the children in.
No one counts the eggs
 they found;
just being there's the win!

Loving Our Neighbor

Faith Andrews Bedford

Mrs. Pearson lived on our land in an old gray cottage whose overgrown yard was enclosed by a sagging fence. Her gardens, Mother said, were once the envy of the neighborhood. Now, we rarely saw her. At Halloween, she would place a bowl of candy on her porch and hide behind her faded curtains. When carolers came to her door at Christmastime, her house remained silent and dark. But every year, when my little sisters and I made May baskets, Mother would urge us to take one to Mrs. Pearson.

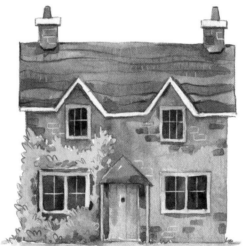

Our other neighbors always made a great fuss. "Look, Arthur," Mrs. Peabody next door would call to her husband. "See what the fairies have left for us." Miss Addie Wilson, in the house across the road, must have listened for our quick knock, for sometimes she almost caught us as we ran to hide behind her azaleas. But Mrs. Pearson never opened her door. Year after year, our little baskets hung on her doorknob until the lilies dangled limply and the daisies turned brown.

The year I turned ten, I begged Mother to let us pass by Mrs. Pearson's house. She just qui-

etly shook her head. "You may not think so, but I know your baskets bring joy to that lonely old lady." So once again, Ellen and I, holding firmly to Beth's chubby little hand, crept up to her door, knocked rather half-heartedly, then scurried behind a bush. "This is silly," I whispered to Ellen. "She never . . ."

"*Ssshhh*," Ellen whispered fiercely, pointing toward the door as it slowly opened. A tiny, white-haired lady stepped onto the porch. She removed the May basket from her doorknob and sat down on the top step with our basket in her lap. Suddenly, she put her face in her hands.

"Oh dear, she's crying!" said Beth, darting out. Mother had put Beth in our charge, so Ellen and I quickly climbed up the steps after her. We found her gently patting Mrs. Pearson's shoulder.

"Are you all right?" I asked with concern.

"Yes, dear, I'm fine," she said as she looked up, wiping her cheek. "You don't know how much I love your little May baskets. I always leave them on the door so all the passersby can admire them." She paused and smiled shyly. "I just got a bit overwhelmed at the happy memories. You see, long

ago, my sister and I used to make May baskets just like these."

Beth continued her patting.

"Would you girls like to come in and have some milk and graham crackers? I could show you pictures of when we were just about your age."

Yes," declared Beth, marching through the open door. Since Mother had told us not to let her out of our sight, we followed.

As we sat in Mrs. Pearson's tidy little parlor eating our graham crackers, she showed us old photographs of her and her sister rolling hoops down sunlit hillsides, playing with their dolls in the woods, and, best of all, the two of them proudly holding their little paper May baskets trimmed with long ribbons.

I wish I could say that, after our visit, Mrs. Pearson began tending her garden again or that she answered the door at Halloween and admired our costumes, but she did not. Nevertheless, for the next several years, until we grew too old to weave paper baskets and

hide behind lilac bushes, each May Day we would climb the steps to her porch and find a little basket just for us. It was full of cookies cut in the shape of flowers with pink frosting and sugar sprinkles.

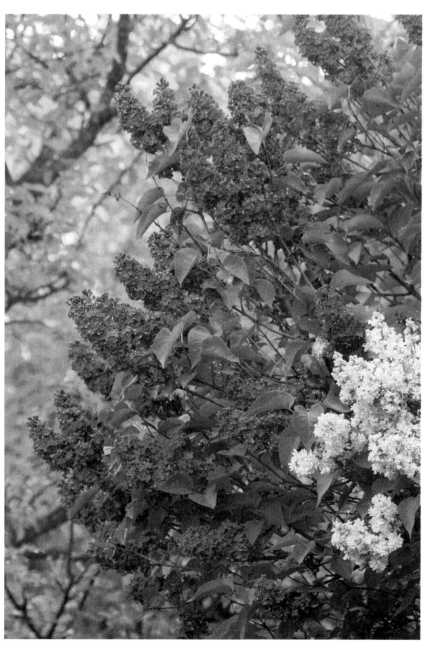

My Neighbor's Roses

Abraham L. Gruber

The roses red upon my neighbor's vine
are owned by him, but they are also mine.
His was the cost, and his the labor, too,
but mine as well as his the joy, their loveliness
 to view.
They bloom for me and are for me as fair
as for the man who gives them all his care,
thus I am rich, because a good man grew
a rose-clad vine for all his neighbors' view.

I know from this that others plant for me,
and what they own, my joy may also be,
so why be selfish, when so much that's fine
is grown for you, upon your neighbor's vine.

My Neighbor's Reply

Author Unknown

Your neighbor, Sir, whose roses you admire,
is glad indeed to know that they inspire
within your breast a feeling quite as fine
as felt by him who owns and tends that vine.

That those fair flowers should give
 my neighbors joy
but swells my own, and draws from there a ploy
which would lessen its full worth,
 did I not know
that others' pleasure in the flowers grow.

Friend, from my neighbors and
 this vine, I've learned
that sharing pleasure means a profit turned;
and he who shares the joy in what he's grown
spreads joy abroad and doubles all his own.

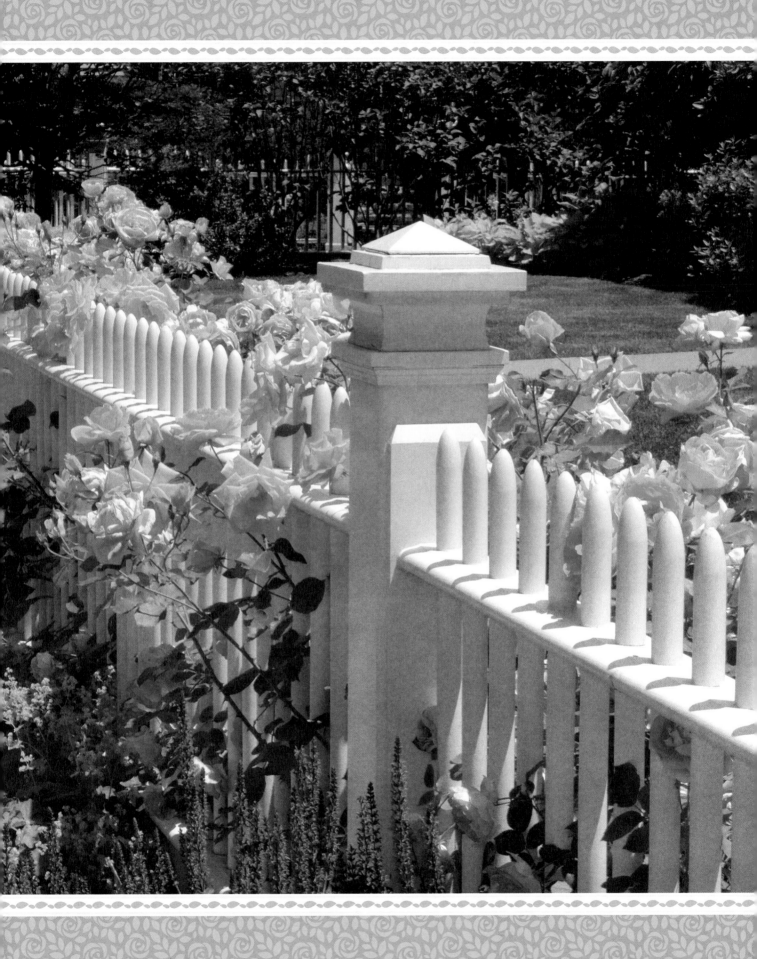

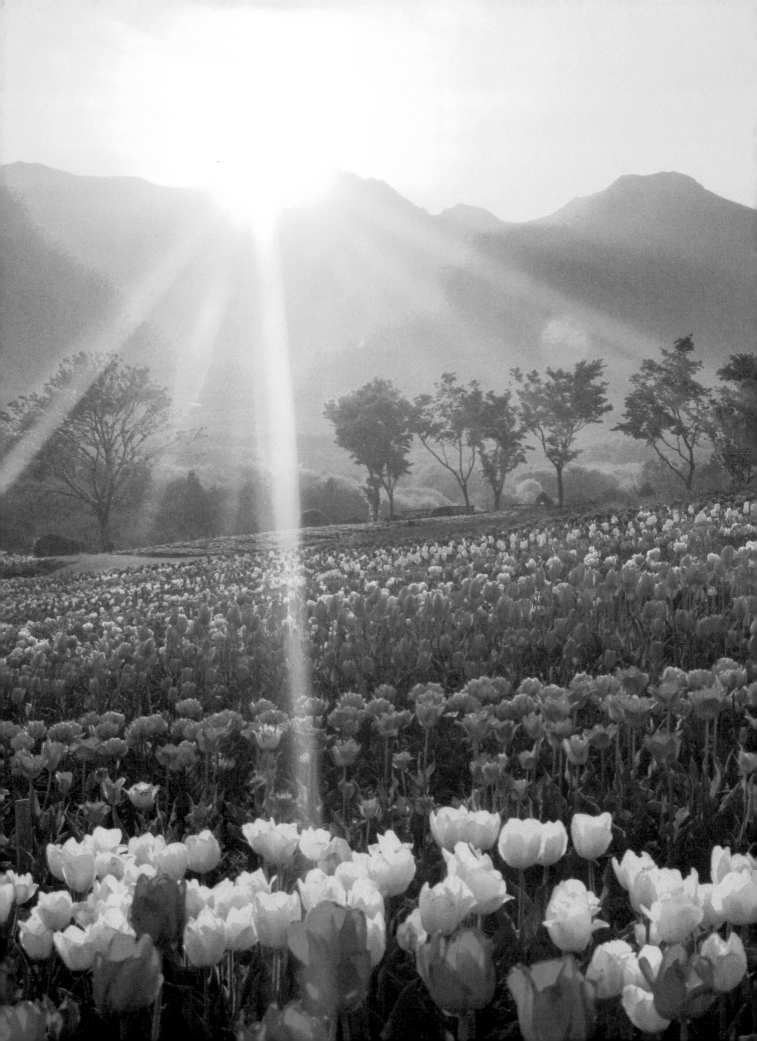

This Is My Father's World

Maltbie D. Babcock

This is my Father's world,
and to my listening ears
all nature sings, and round me rings
the music of the spheres.
This is my Father's world:
I rest me in the thought
of rocks and trees, of skies and seas—
His hand the wonders wrought.

This is my Father's world:
the birds their carols raise,
the morning light, the lily white,
declare their Maker's praise.
This is my Father's world:
He shines in all that's fair;
in the rustling grass I hear Him pass,
He speaks to me everywhere.

This is my Father's world:
O let me ne'er forget
that though the wrong seems oft
 so strong,
God is the Ruler yet.
This is my Father's world:
why should my heart be sad?
the Lord is King: let the heavens ring!
God reigns; let earth be glad!

The Inevitability of Spring
Betty Rosian

Hold fast, my soul, to joy today,
so fleeting this gentle season;
and thank the Lord for
what we know
will surely dawn upon us
as before,
the long-awaited,
longed-for day,
the inevitability of spring.

ISBN: 978-1-5460-0357-1

Published by Ideals
Hachette Book Group
1290 Avenue of the Americas
New York, NY 10104

Printed and bound in the U.S.A. · LSC-W

Publisher, Peggy Schaefer
Senior Editor, Melinda Rathjen
Editor, Patricia A. Pingry
Designer & Photo Research, Marisa Jackson
Associate Editor & Permissions, Kristi Breeden
Proofreader, Amanda Varian

Cover: Garden of Design in Spring, Keukenhof, Netherlands. Image © Cornelia Doerr Image/SuperStock
Additional art credits: Art for "Bits & Pieces" by Emily van Wyk
Inside front cover: *Blooming Trees* by A. Burkatovski/SuperStock
Inside back cover: *In Voorhees' Garden* by Matilde Browne/Bridgeman Images

Want more homey philosophy, poetry, inspiration, and art? Be sure to look for our annual issue of *Christmas Ideals* at your favorite store.

Join a community of *Ideals* readers on Facebook at: www.facebook.com/IdealsMagazine
Readers are invited to submit original poetry and prose for possible use in future publications. Please send no more than four typed submissions to: Hachette Book Group, Attn: Ideals Submissions, Hachette Nashville, 830 Crescent Centre Drive, Suite 450, Franklin, Tennessee 37067. Editors cannot guarantee your material will be used, but we will contact you if we do wish to publish.

ACKNOWLEDGMENTS

MILNE, A. A. "Wind on the Hill," copyright © 1927 by Penguin Random House LLC. Copyright renewed 1955 by A. A. Milne; from *Now We Are Six* by A. A. Milne. Used by permission of Dutton Children's Books, an imprint of Penguin Young Readers Group, a division of Penguin Random House LLC. All rights reserved. MARSHALL, PETER. "Easter Grace," from *The Best of Peter Marshall* by Peter Marshall, copyright © 1983. Used by permission of Chosen Books, a division of Baker Publishing Group. TABER, GLADYS. "Easter At Stillmeadow" from *The Best of Still Meadow* by Gladys Taber. Copyright © 1976 by Gladys Taber. Renewed 2004 by Constance Taber Colby. All rights reserved. Used by permission.

OUR THANKS to the following authors or their heirs for permission granted or for material submitted for publication: Faith Andrews Bedford, Deborah A. Bennett, Johnielu Barber Bradford, Anne Kennedy Brady, Anne Campbell, Marianne Coyne, Joan Donaldson, Gary A. Fellows, Abraham L. Gruber, Clay Harrison, Rebecca Barlow Jordan, Pamela Kennedy, Pamela Love, Andrew L. Luna, Amannda Gail Maphies, Madeleine Mills, Charlotte Partin, Betty Rosian, Eileen Spinelli, William L. Stidger, Mary Wells

Scripture quotations, unless otherwise indicated, are taken from ESV® Bible (*The Holy Bible, English Standard Version®*), copyright © 2001 by Crossway, a publishing ministry of Good News Publishers. Used by permission. All rights reserved.

Scripture verses marked NIV taken from the *Holy Bible, New International Version®, NIV®*. Copyright ©1973, 1978, 1984, 2011 by Biblica, Inc.™ Used by permission of Zondervan. All rights reserved worldwide.

Every effort has been made to establish ownership and use of each selection in this book. If contacted, the publisher will be pleased to rectify any inadvertent errors or omissions in subsequent editions.